An Eye for Beauty

An Eye for Beauty

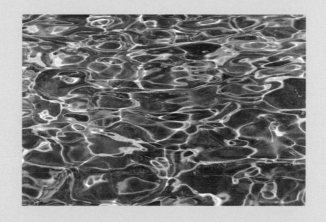

EVELYN H. LAUDER

INTRODUCTION BY AMY SPINDLER

Harry N. Abrams, Inc., Publishers

The author's royalties from the sale of *An Eye for Beauty* will be donated to The Breast Cancer Research Foundation.

The Breast Cancer Research Foundation, a not-for-profit 501 (c)(3) organization, was founded in 1993 by Evelyn H. Lauder, Senior Corporate Vice-President of the Estée Lauder Companies, and is the first and largest national organization dedicated solely to funding clinical and/or genetic research in breast cancer at major medical centers across the country. A minimum of 85 percent of all funds raised goes directly to research.

 The Breast Cancer Research Foundation receives contributions from individuals, foundations, and corporations to fund important research on breast cancer by stellar medical scientists across the United States. These dedicated and gifted researchers are working hard to find new cures, better methods of diagnosis, and targeted treatments. Exciting potential prevention strategies are currently being funded in gene sequencing in order to be able to create vaccines in the not-too-distant future. The efforts of these researchers will improve the lives of those who are living with breast cancer, and the many millions of women (and men) for whom we want to guarantee a lifetime free from the disease.

THE BREAST CANCER
RESEARCH FOUNDATION

A CURE IN OUR LIFETIME®

For information:

The Breast Cancer Research Foundation
654 Madison Avenue, Suite 1209
New York, NY 10021
Telephone: 646-497-2600
Fax: 646-497-0890
www.bcrfcure.org

Editor: Barbara Burn
Editorial Assistant: Josh Faught
Designer: Joel Avirom
Design Assistants: Meghan Day Healey and Jason Snyder
Production Coordinator: María Pía Gramaglia

Library of Congress Control Number: 2002105665
ISBN 0-8109-3284-9

Published in 2002 by Harry N. Abrams, Incorporated, New York

Printed and bound in Hong Kong
10 9 8 7 6 5 4 3 2 1

Harry N. Abrams, Inc.
100 Fifth Avenue
New York, N.Y. 10011
www.abramsbooks.com

Abrams is a subsidiary of

LA MARTINIÈRE
GROUPE

CONTENTS

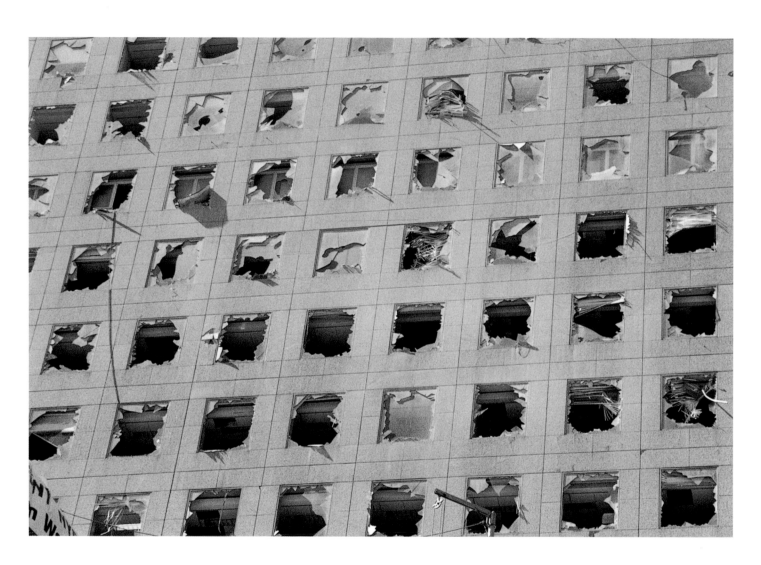

Broken, September 26, 2001, Ground Zero, New York City

My MISSION IN THIS BOOK is to share with you the possibilities of a heightened delight in everything that surrounds you—for example, by noticing and observing the light and how it plays through the leaves or the grass—as if it were the last day you could see these things.

In my first book, *The Seasons Observed*, we took a look at the four seasons in a relatively distant way, but with the same thought—to open our eyes to pattern, design, light, even drama in our everyday beautiful world. My goal there was to give the reader the chance to commune with nature, to use my photographs to calm anxiety, to find balance and harmony in the ever-changing, always-present landscape. There were no images of people in that book, or of anything made by man.

In this book, we are still going to look at amazing moments in nature, when the light is just perfect, but we will also see abstract patterns created by the hand of man. If you will indulge me, I will also share some personal memories of journeys taken to far-away places in the process, including one image in which we can see the human presence as an expression of evil, a moment when we were all made suddenly aware that hate had taken a new form. My photograph of one of the buildings damaged in the attack on the World Trade Center doesn't really belong in this book, but I could not bring myself to leave it out. Like the lives of so many, my life and my work on this book were interrupted, and my inclusion of this picture is my way of documenting the tragedy and ensuring that none of us will forget that moment.

An Eye for Beauty isn't just about seeing beauty, relationships, and light. It is intended to give us insight into our lives, past, present, and maybe our future.

Evelyn H. Lauder
New York, March 2002

ACKNOWLEDGMENTS

A number of people gave me sound advice in the preparation of this book. Two people stand out most. The first is my talented husband, Leonard, who is always encouraging as well as honestly critical and insightful. He has a discerning eye and a swift perception. The second is the patient and cheerful curator Alice Momm, who showed a talent for seeing the possibilities as we debated the merits of each photograph during the selection process. I am also deeply grateful to Holly Solomon, the art dealer, who hosted my first exhibition in 1992. It was her encouragement that helped me to continue to develop my eye. I have asked for advice and received it from a few friends, including Paul Gottlieb, my editor Barbara Burn, Arthur Klebanoff, Mayor Mike Bloomberg, and Amy Gross, Editor in Chief of *Oprah Magazine.* In some cases I was able to act on their suggestions, and in other cases, I listened. In all cases, I am extremely grateful to each of them.

My most sincere thanks to the talented Joel Avirom whose nimble eye provided the layouts and cover design for the book. He brought a sensitive perspective and helped to bring out the best of the photographs, which made the book more beautiful than I imagined it could be.

Special thanks go to Ingrid Sischy, who has been by my side as a friend and as an expediter of many favors. Her ideas also provided some of the background for Amy Spindler's introduction.

I am extraordinarily indebted to Amy herself. In spite of her incredible schedule as Style Editor of *The New York Times Magazine,* she took her valuable time to write the flattering and interesting foreword— a must-read before seeing the images. Amy's words define my goals better than I could have ever expressed in these pages.

INTRODUCTION

AMY SPINDLER

EVELYN LAUDER never misses a thing. This characteristic makes it very fun to be her friend, but must make it awful to be her accountant. It also makes her a wonderful photographer. A photo can't transport you unless you can be transported by the photographer's way of seeing. If Evelyn was not a camera, she'd be a telescope and a microscope. Paging through her photos is like spending a luxurious day with her as she makes you look. No, really look. At the shadows wicker throws across the awning stripes of a chair. At the luminescent icicles decorating an iron grating. At moss making a beard on a tree. It's tempting to think of many of the photos as an exquisite travelogue, but the photos don't encourage travel as much as they encourage you to live. To embrace the world around you, the details of which, taken all together, make life worth living. Because you could be at Niagara Falls, and there would be tourists and guys hawking T-shirts and neon signs and tacky hotels, and you might never notice the lava-lamp liquidity of the roiling water. Or the cottony trim the surf puts on each wave. Evelyn saw that. Evelyn makes you see it, too.

Spending as much time as I do as a style editor watching photography happen, it continually amazes me how much weight has gone into it of late. I don't mean the weight of the meaning, which is of course a part of it, but the weight of the process. The size of the equipment, the lights, the assistants. And then afterward, there's the retouching and post-production airbrushing and photo shopping. It brings to mind Lawrence Olivier's comment on hearing about Dustin Hoffman's preparations for the film *Marathon Man*. Among his laborious methods for a scene, Hoffman had kept himself up for two days. "Dear boy," Olivier said. "Why don't you just try acting?" In taking her photos, Evelyn Lauder just acts. It's true that her state of mind is revealed in her subjects, which are in themselves revealing of how this very busy woman very studiously slows down to take in the world. And then, because she is at heart so generous, she lets you take it in too.

But as much as Evelyn's photos are about looking, they are about seeing. I've been to many of the places Evelyn captures, yet I don't feel, now, looking at her work, as if I ever saw them at all. Her photos are so

alive that they don't feel like photos at all; they feel like she's slowed down the molecules of the moment to give you a chance to drink it in. If anyone has been-there-done-that, it's Evelyn, and yet, since photos are truth, these tell an amazing one: she never gets bored, or jaded, or tired. She's looking at CLOUDS. And ordaining them as subjects. The truth of these photos is that Evelyn uses her camera to find places of peace. That she's still sitting and looking at the sky. That she can get excited about the play of shadow and the pattern of light. Within a life where she also has occasion to have Harrison Ford to dinner and New York's toughest mayor say, "When Evelyn calls, I come," these photos are a document of what she find exciting when no one's watching. When the party's over, and the mayor has gone home, and Evelyn seeks a moment of peace, she takes a photo.

There is a closing chasm in the culture right now between what we believe is art photography and what we believe is photojournalism. Certainly that merging lies in photography of the horrific, like the World Trade Center images, which undeniably change forever our reaction to any photograph. I would argue that those images make the antidote even more compelling. Those harsh realities of the best award-winning grotesques, exhibited already regularly in galleries, are truth. But truth is also the ragged promontories of Torre del Paine in Patagonia. Truth is also the light playing over the pebbles of the Roaring Fork River. Truth is also the palms and their trunks making a fabulous abstract reflected in the waters of Palm Beach. Do we respect ugly truths more than beautiful ones? Photography criticism has leaned toward that. As Evelyn sees the seasons change, and captures what she calls the glorious gold of the leaves, or the tulips which look to my city eyes as bright as neon signs, she captures them. And they're truth. And we need these images more than ever now. Ingrid Sischy's seminal piece in *The New Yorker* many years ago questioned the merging of the tenets of beauty and photojournalism, when Sebastião Salgado's images made suffering an aesthetic, fettishising it to the point where visitors to an exhibit can look at a starving person and say, "How beautiful!" Sischy, a renowned photographic critic, dryly said that the road to hell is paved with good intentions and that by capturing the suffering so beautifully the photos became artistic still lives instead of calls to action. Yet Evelyn's artistic still lives are a call to action. You don't need to be a botanist or an anthropologist or an environmentalist to understand that nature is as endangered as the people Salgado photographed.

Photos like Evelyn's are beauty as the salve for suffering. You can't say they're not photojournalism; they document what is real. And the way the environment is heading, they are their own sort of diary of our times, which are a-changin'. And yet, in another important piece of photographic criticism, Sischy also took

on the American school of nature photographers like Minor White, who used nature as a metaphor. I say "used" with the bit of contempt Sischy felt. Why does nature have to be metaphor for anything? Surely nature as a subject on its own deserves to represent itself. Evelyn never "uses" nature. She loves nature for what it is, for the calm it brings her, for the way she must feel when she sees her images for the first time, miles away in time and distance from the moment she framed the shot.

Evelyn is a straight shooter in every respect, and she used to say she was "a total amateur" when she talked about her photos. Note to Evelyn: You can't say that any more, dear. The first photo I saw in the series was a translucent leaf she shot in Ecuador in 1999. From a photographic standpoint, it is certainly the master-piece of the book. I would like to see it blown up Andreas Gursky sized. But it was on top of my desk, and I didn't realize it was Evelyn's and I didn't even realize it was a leaf. It at first struck me as a highway divided by fields. Then it struck me as a detail of a piece of machinery. All my references were to man and the way he grabs the symmetry and lines that nature taught him and uses those references to destroy nature. Needless to say, I was very happy to discover it was a leaf. Delirious, in fact.

There's a school of art criticism that argues that work should be viewed divorced from the personality who made it; that the artist-as-celebrity of Jackson Pollock in *Life Magazine* has polluted criticism. And I encourage you to forget about who Evelyn is at first, and be lost in these photos as photos that transport. But then I encourage you to be awed by what else they represent, which is a commitment to preserving both these visions on film, and her vision of what her life should be. And is. In a time when we want to put everyone in a box, because it's easier for us to deal with stereotypes of the Corporate Titan, the Fashionable Socialite, the Loving Wife, the Good Mother, and the Bleeding Heart Philanthropist, Evelyn will not be put in a box. She is all of those things, true, sometimes. But her work in photography is a strong, decisive statement on her part. Her camera has not only given her the ability to operate freely in yet another world, it has offered her yet another world to feel at home in. Like her cloud formation photo (she sees a whale), many of the works in this collection are impressionistic. Yet I defy anyone who looks through its pages, really looks, to not end the journey by making plans to take a trip to some uninhabited nirvana.

She is an avid art collector, and the works she loves inform her photography as much as nature does. In Evelyn's apartment, she has real stuff hanging around that most of us had as posters in our dorm room. So when she references a Rothko, she knows whereof she speaks, as they say. When I came across her "Rothko's

Sunset, January 1997," I got my Rothko book off my bookshelves (which have replaced my dorm room posters) and found *Painting Number 7, 1960*, which Rothko considered one of his greatest works and he never sold. Evelyn knows all about Rothko, and Rothko knew all about sunsets. And her photo offers proof.

One of my favorites in this collection is "Balconies, Laundry Banners, Havana, December 1998." Knowing Evelyn as I do, one of the greatest pleasures I have in looking at the photos is imagining her in these places. The perspective of the photo gives me a photo in my mind of Evelyn, head tipped backward, craning up at the sky.

Or again, from the Cuba series, "Busy Gates," which is a celebration of a wooden gate carved with graffiti, and behind the spindles in the windows, we can see people standing in colorful clothes. Evelyn makes even her busy gates seem peaceful. But for me, its Evelyn singling out the gates, standing there and capturing the monument to themselves carved by Rafael Calluja, and Pepe from P.R. (Puerto Rico) and Manuel, and Carlitos Roman. Ultimately, photography is about choice; what the photographer captures, and what she doesn't capture. Evelyn chose to capture Pepe from P.R.'s gift to the gates.

I had an occasion to write a story about Evelyn recently for *The New York Times Magazine*, and owing to the ethics of the institution, felt compelled to open it by noting, "Full disclosure: Evelyn Lauder saved my life." With her fundraising for cancer research, there are many people who can say that, and articles still must be written. So I'm compelled to offer this full disclosure as well: Mostly, I love Evelyn's photos because I love Evelyn. It's her fault, of course, that her utterly charming generous personality makes me love her so, and creates this conflict of interest. But fortunately, her embrace of life, her vast understanding of art, her curiosity about the world at large, and her ability to isolate the beauty in any situation, are the informing principles of her photography. So the converse works: if you love Evelyn's photos, you'll love Evelyn too. Which is what personal vision in photography is all about.

I look at the rat race full of rats and the politics of art and the commercialization of the culture, and I feel good to see Evelyn's photos reach the stage every time. It's true that Evelyn's other art, her business acumen and her philanthropy, does get a lot of attention. Wouldn't it be great if we could hang that on the wall and admire the lives she's saved, the lives she's changed.

Whoever said God doesn't give with both hands obviously never met Evelyn Lauder. But then, maybe God only gives with both hands when the person gives back.

An Eye for Beauty

Sky

LET'S START with the sky. Everyone thinks the sky is blue, but is it really? A watchful observer will see amazing changes, colors, and forms in this stuff that surrounds our globe. It's there for every human to see all the time, year in year out, and it never ceases to amaze.

As a tiny child, while fleeing Austria in the middle of the night, I recall waking up in my father's arms, feeling the soft night breeze on my cheeks and seeing stars for the first time in my life. It was a riveting experience that I have never forgotten. I asked my father what was up there, and he answered me with a new word, "sky."

As time passed, my fascination with the sky expanded as I learned about weather, clouds, and the solar system. The mystery of the formation of worlds might one day be solved by what lies so far beyond our own world, beyond our immediate view of the sky. We all need to see the sky every day and to feel the light of the sun.

These photographs try to capture some of the infinitely variable colors and drama of what I first saw in my father's arms so many years ago.

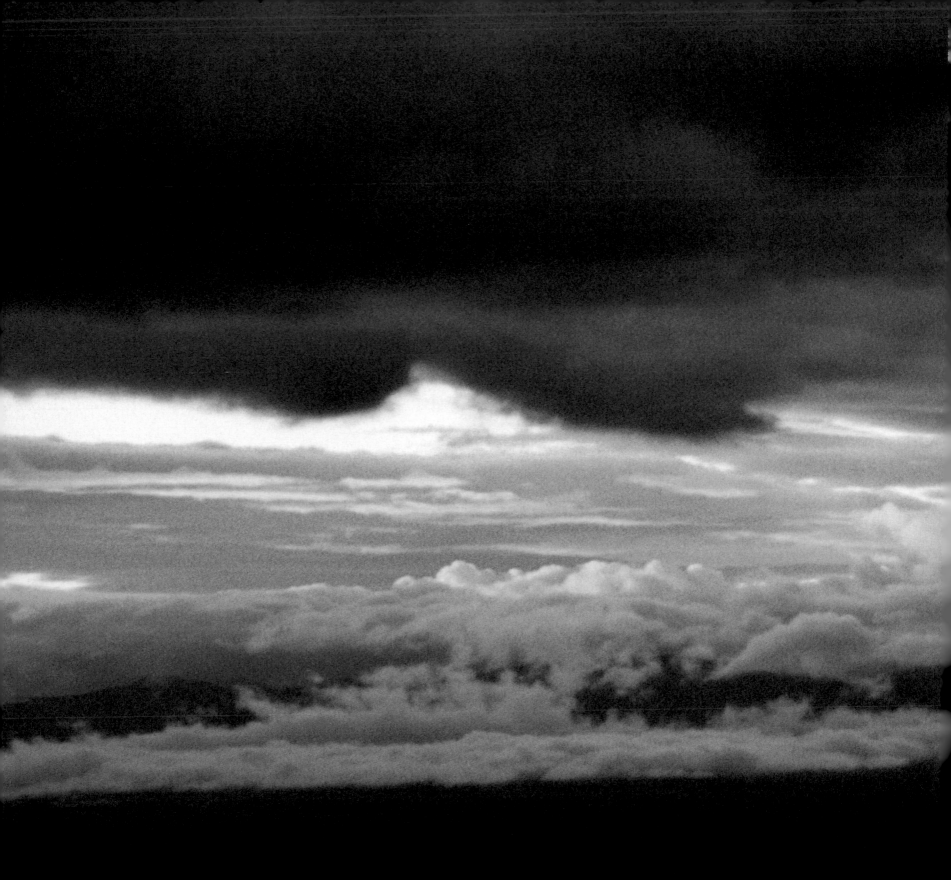

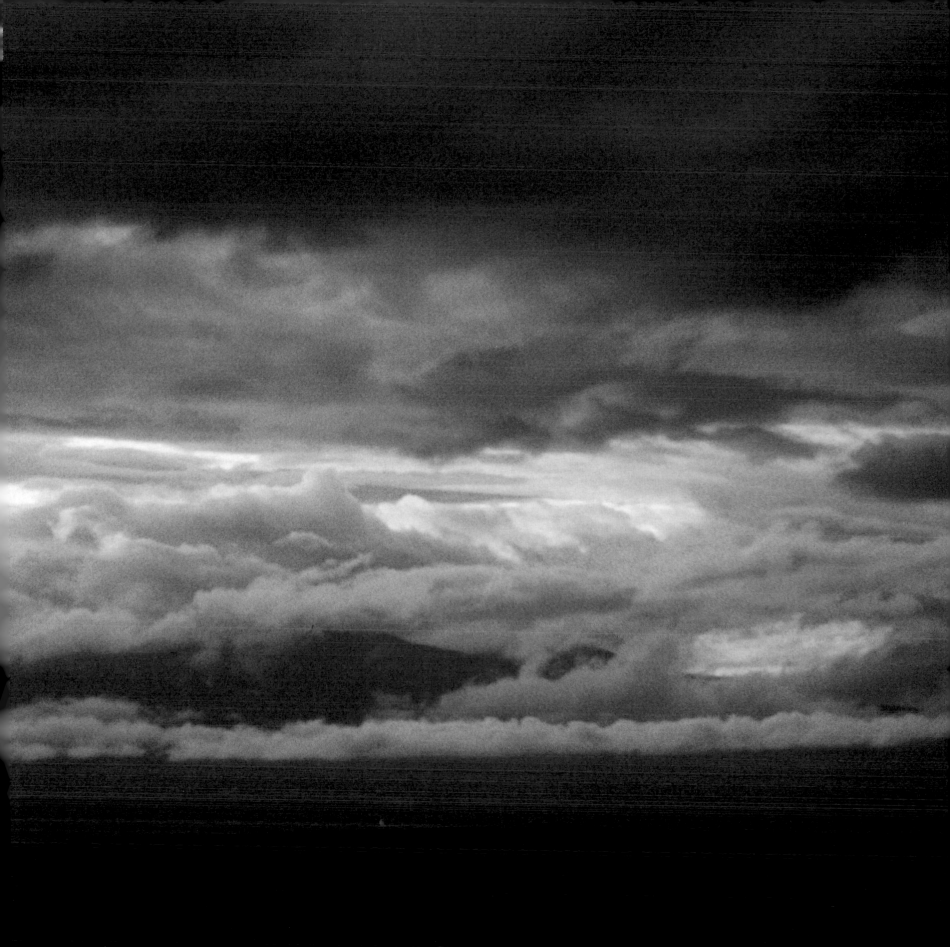

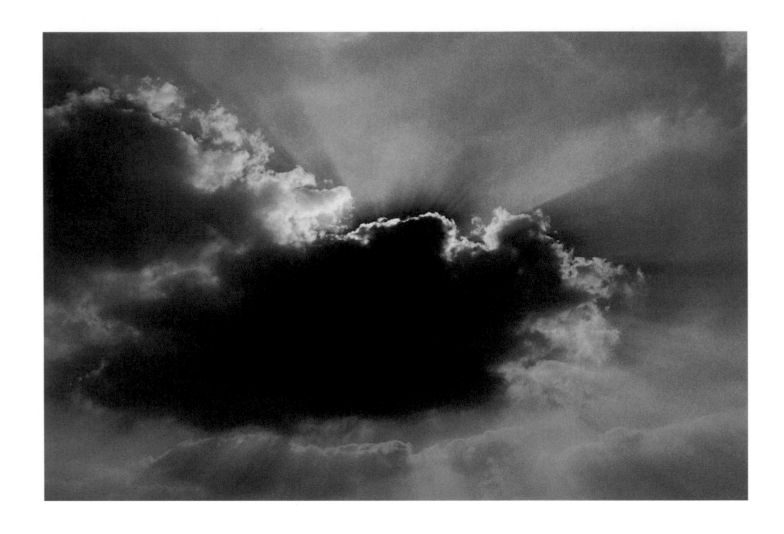

Glory Cloud, Sky Over England, September 1999

———

New Millennium Sunset, Anguilla, 1999

Blue and Pink Clouds, New Mexico, 1995

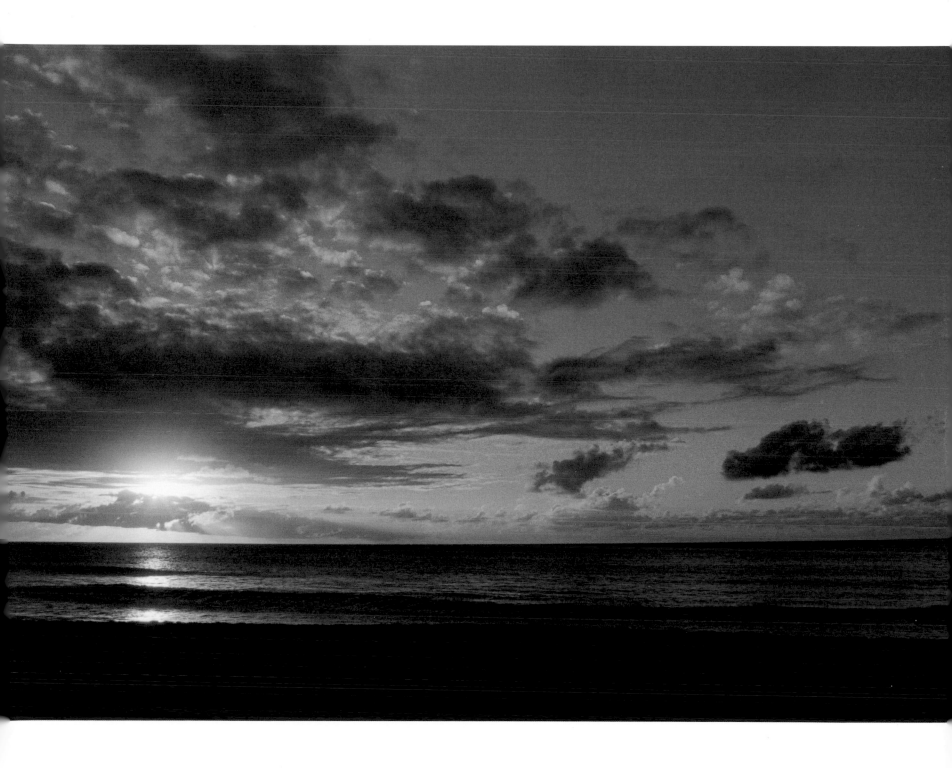

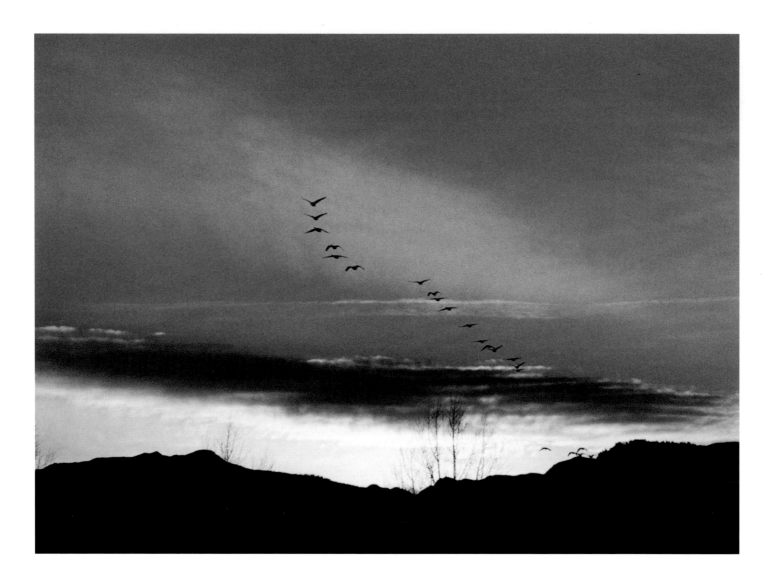

Ducks in the Sky, Colorado, Autumn 1996

———

Whale in the Sky, Colorado, Autumn 1996

———

Snow in the Sky, Autumn 1996

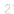
21

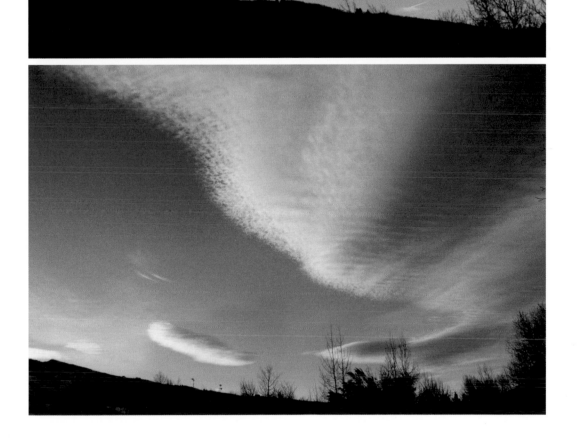

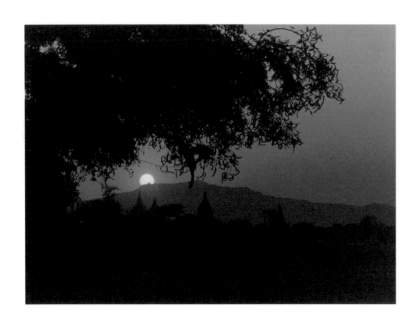

ABOVE

Myanmar Temple Sunset, March 1998

———

RIGHT

South American Sunset,
Porto Varas, Chile, February 1999

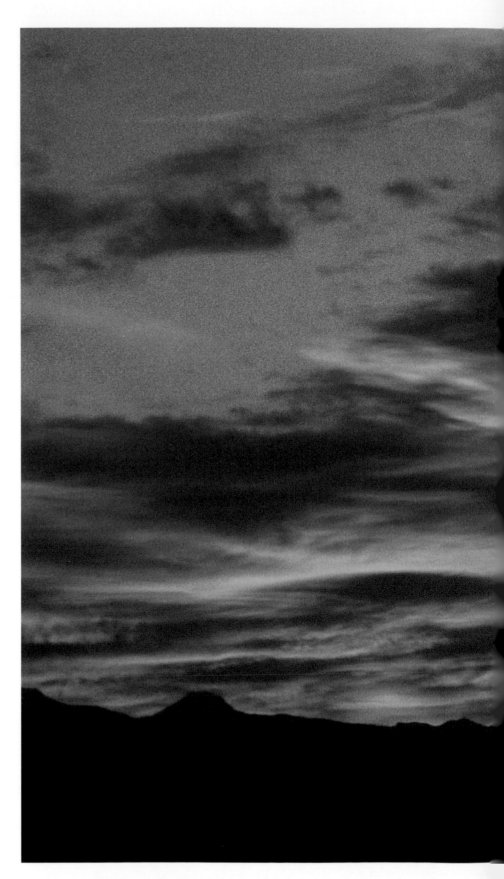

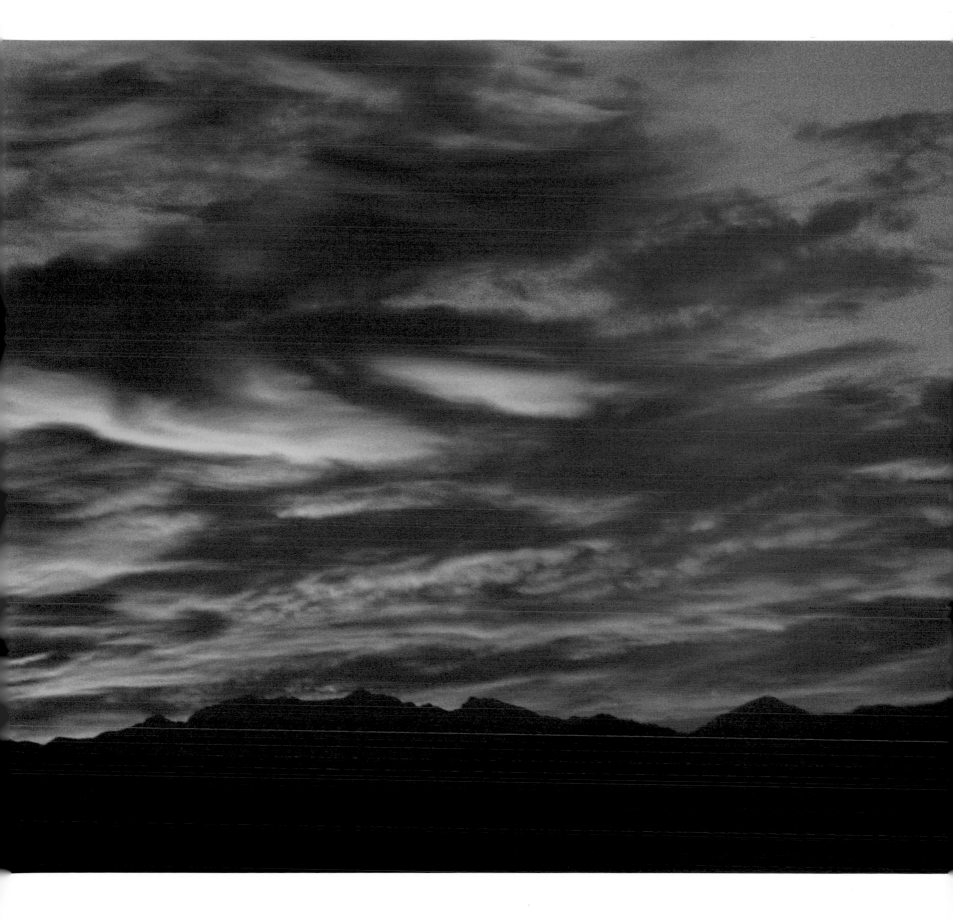

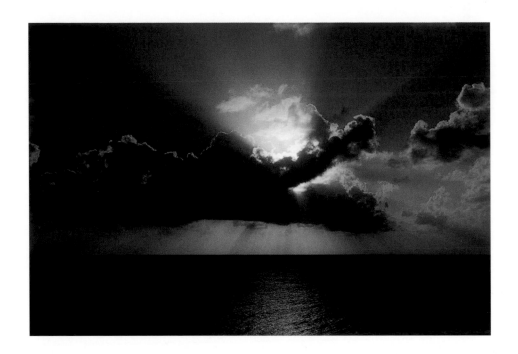

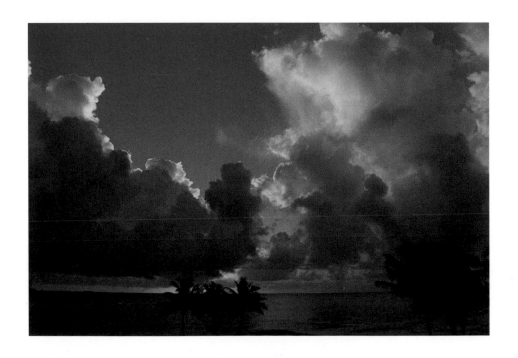

ABOVE LEFT
Galapagos Sunset, February 2000

———

LEFT
Beach Sky, Palm Beach, Florida,
January 1999

———

OPPOSITE
Layered Sunset,
Malliouhana, February 2001

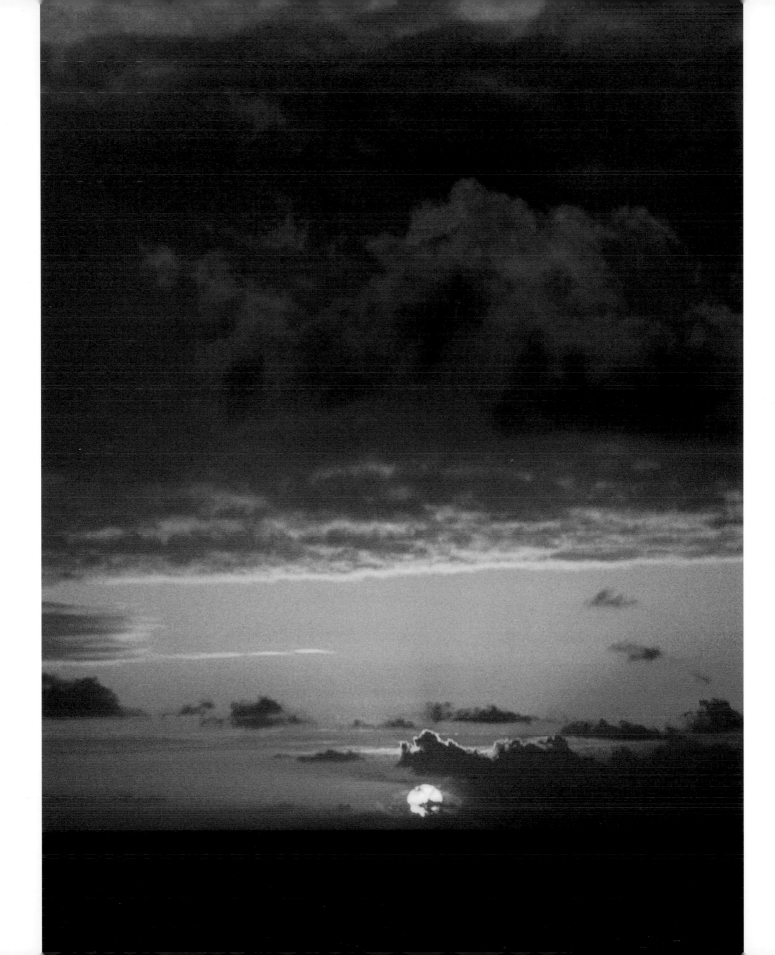

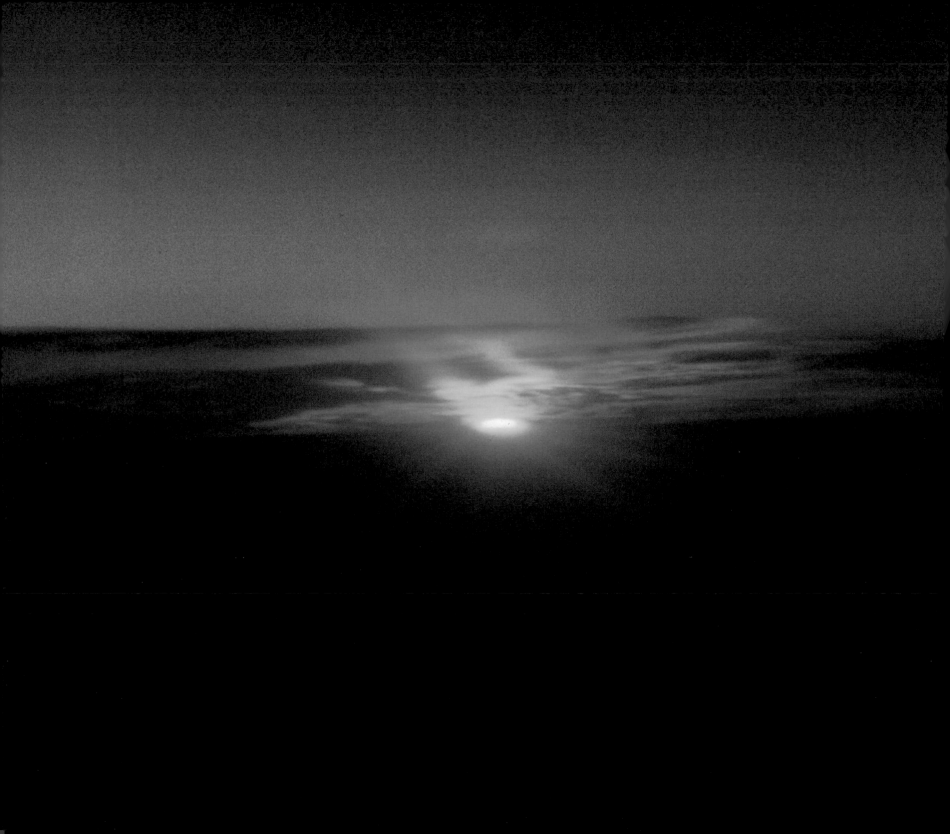

27

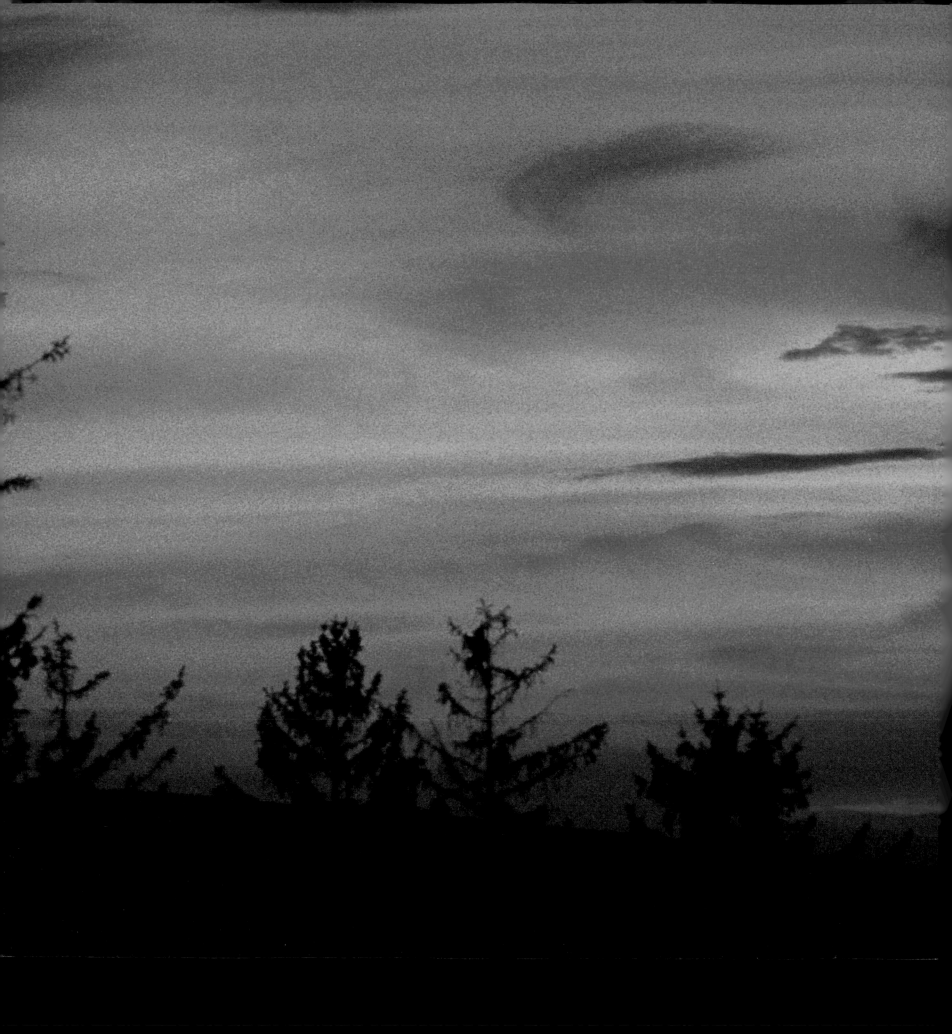

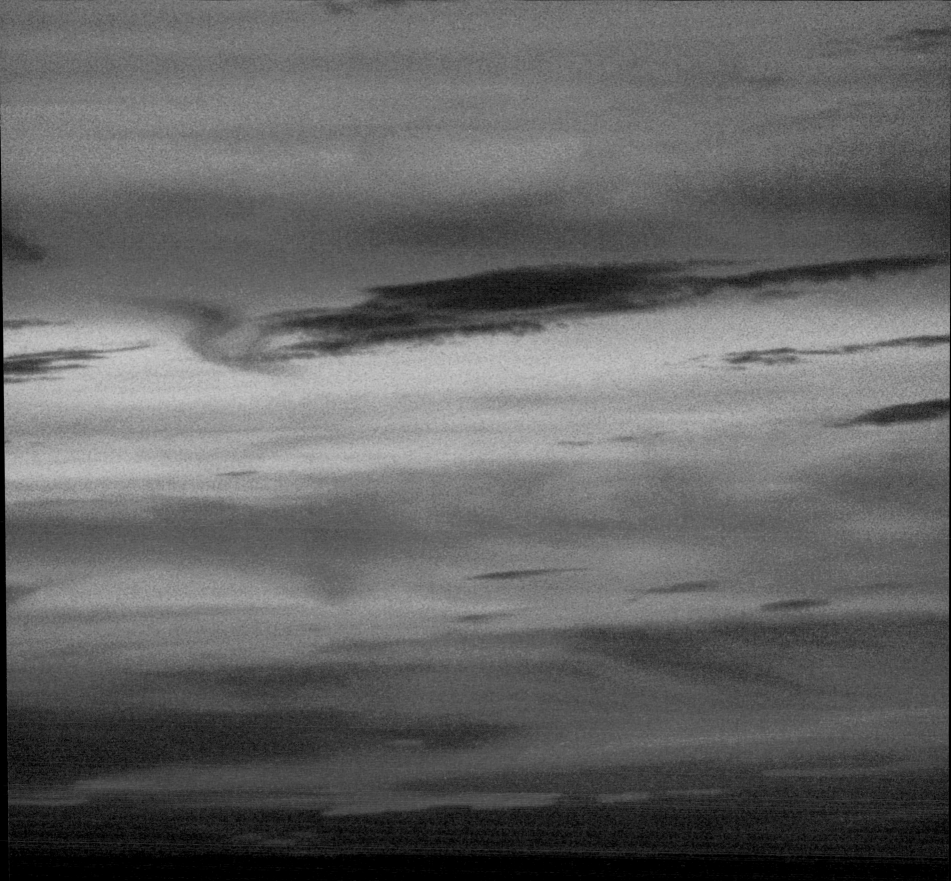

Vistas

ONE OF LIFE'S most enjoyable experiences is to see the world from one end to the other. Along the way, marvelous views unfold before the traveler's eye. For example, in South America, one of the greatest geological outcroppings is Torre del Paine in Patagonian Chile, especially impressive when seen from the north. This land must be where air is born, since the wind is unrelentingly constant and strong. Trees grow slanted in its path, and if you put out your arms into the wind, you can almost imagine taking off yourself.

In Venezuela, there is a waterfall called Angel Falls, which is the longest waterfall in the world. It is extremely unusual to be able to see it as we did with our friends Patty and Gustavo Cisneros. We landed at the base of the falls (before the government suggested that this not be done) after flying in a helicopter above the Tepui cliffs in the Valley of the Devil—Cañon del Diablo—which in itself was an experience and a half. We picnicked at the falls in our bathing suits with the finest wines, linen napkins, and beautiful food, and then we sat under the falls for a good drenching. A popular tourist attraction, the falls are never visited privately unless people climb to it. What a thrill to go in such style.

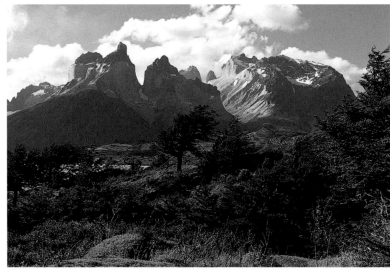

ABOVE

Torre del Paine, Patagonia, Chile, February 1999

———

RIGHT

Torre del Paine II, Patagonia, February 1999

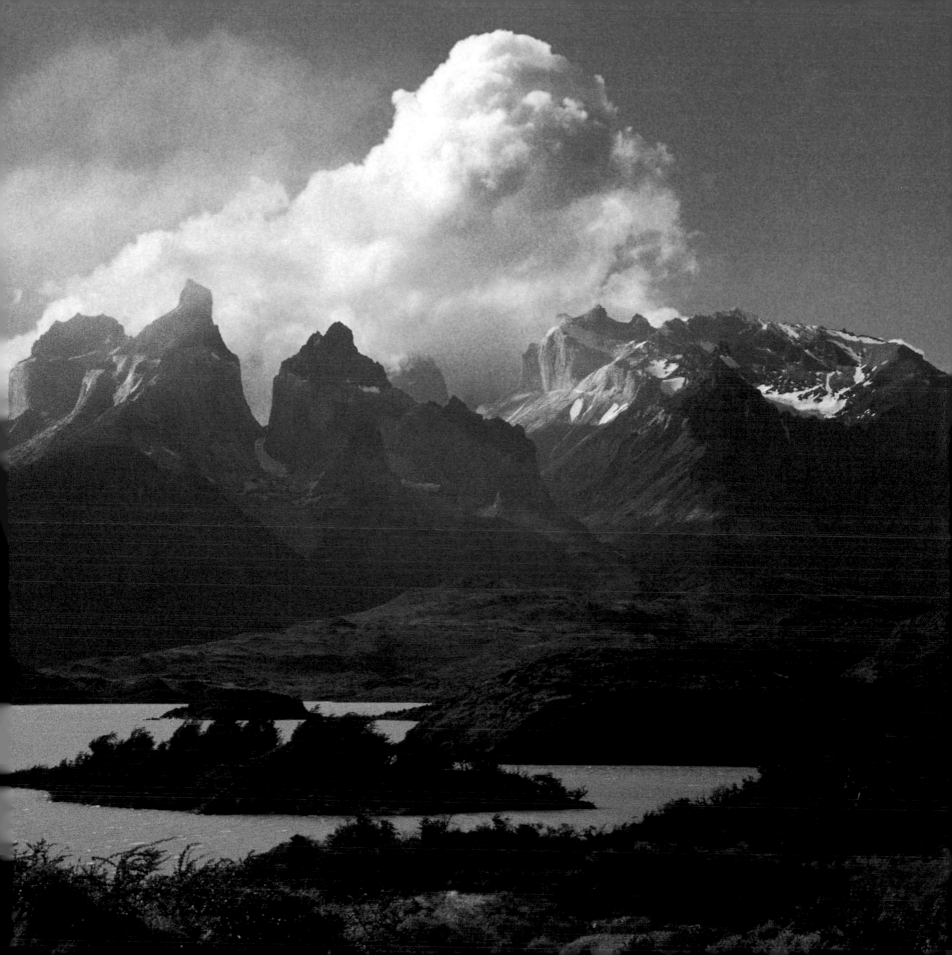

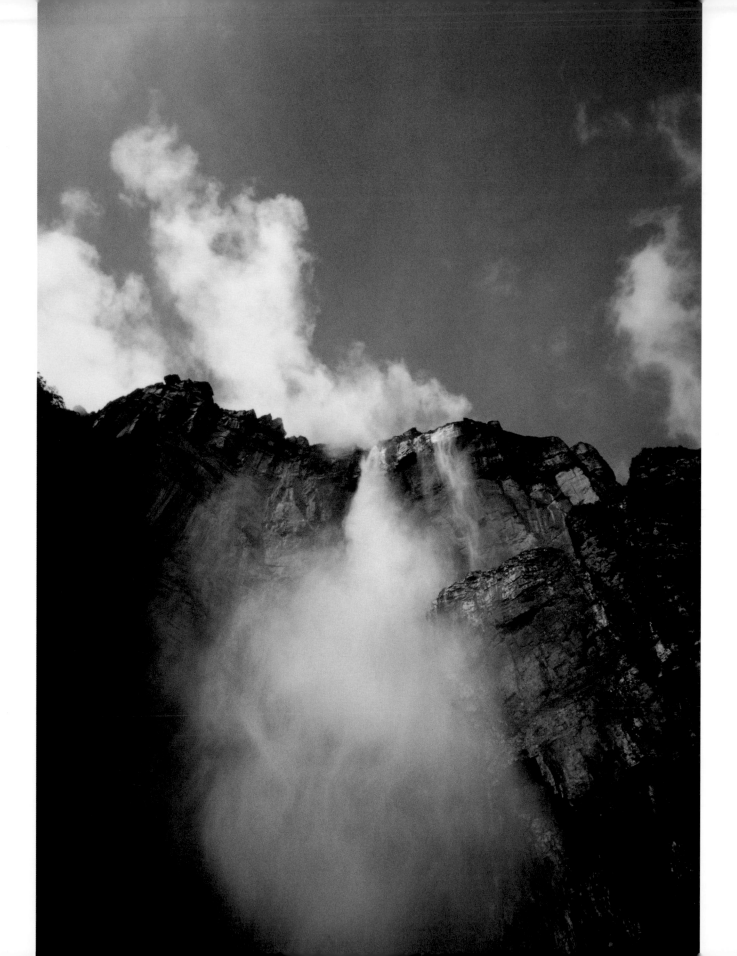

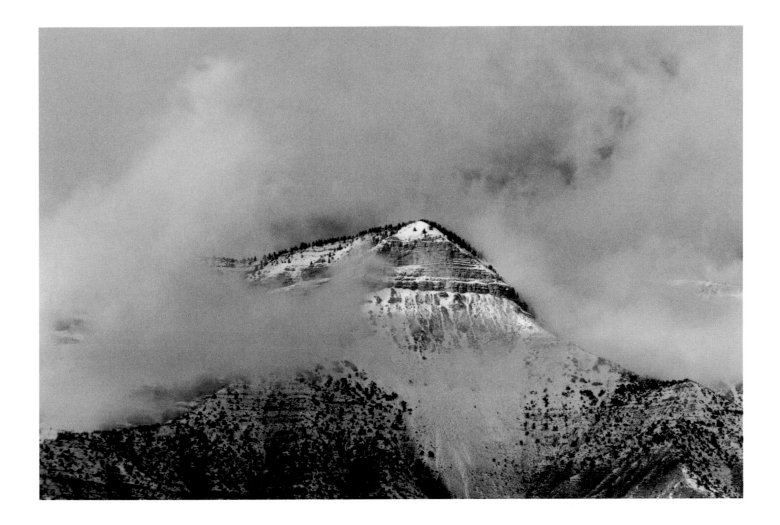

OPPOSITE

Angel Falls, Cansima National Park, Venezuela, 1997

———

ABOVE

Peek a Boo II, Colorado, 1996

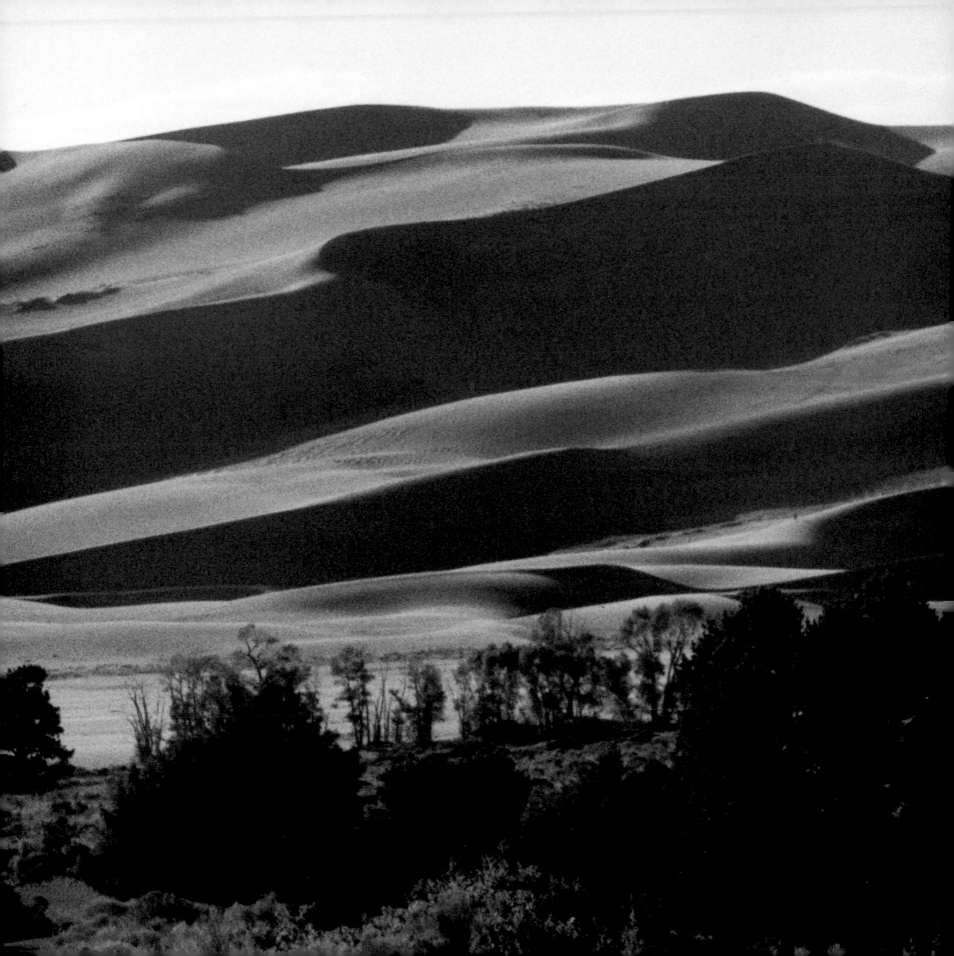

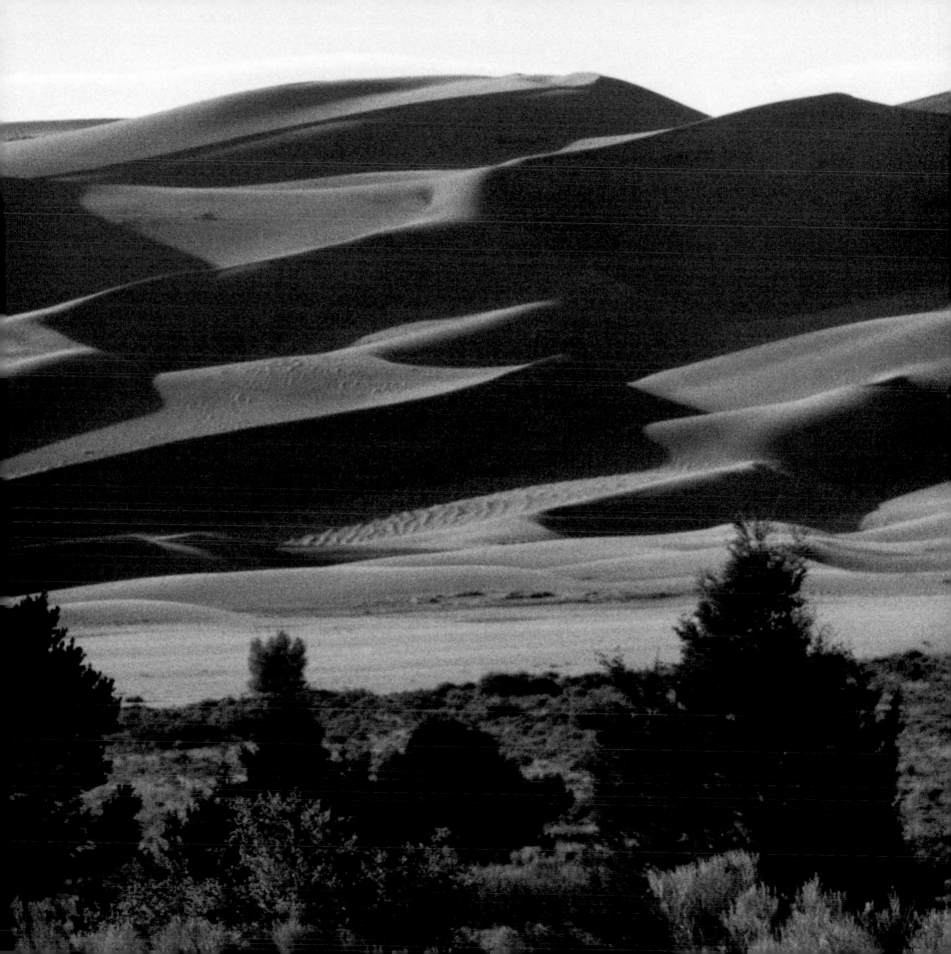

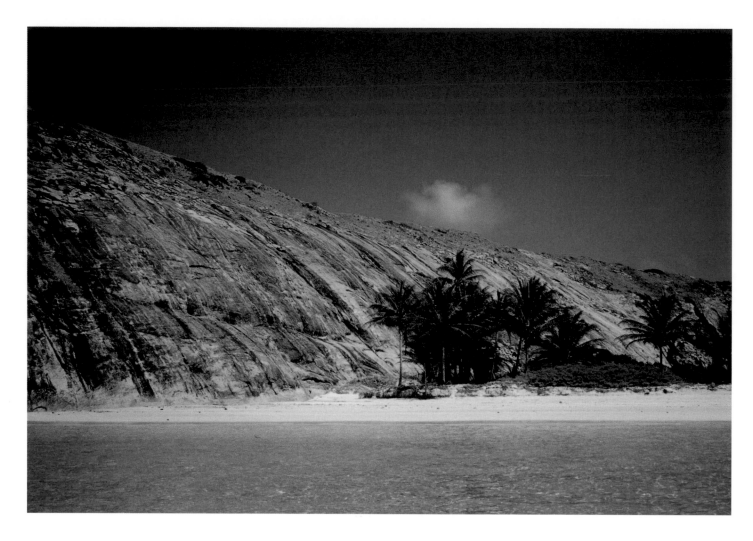

Lizard Island, Great Barrier Reef, Australia, October 1988

———

OPPOSITE
The Atacama, Chile, November 2000

PREVIOUS SPREAD
Sand Dune National Park Shadows, Colorado, July 1996

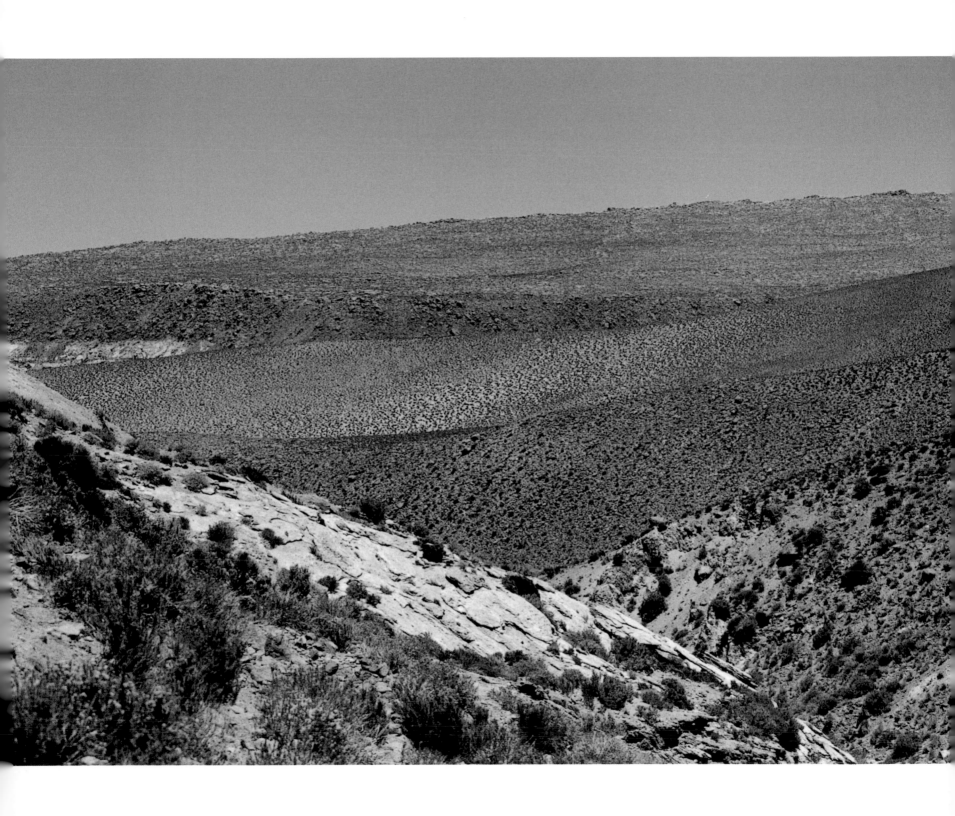

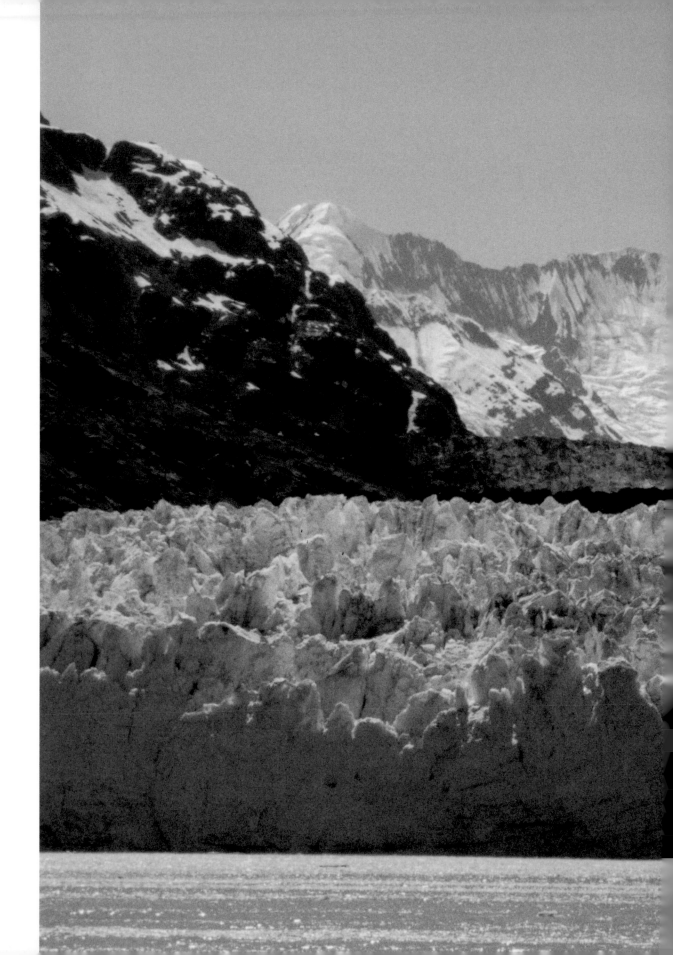

Glacier Calving, Alaska, June 1998

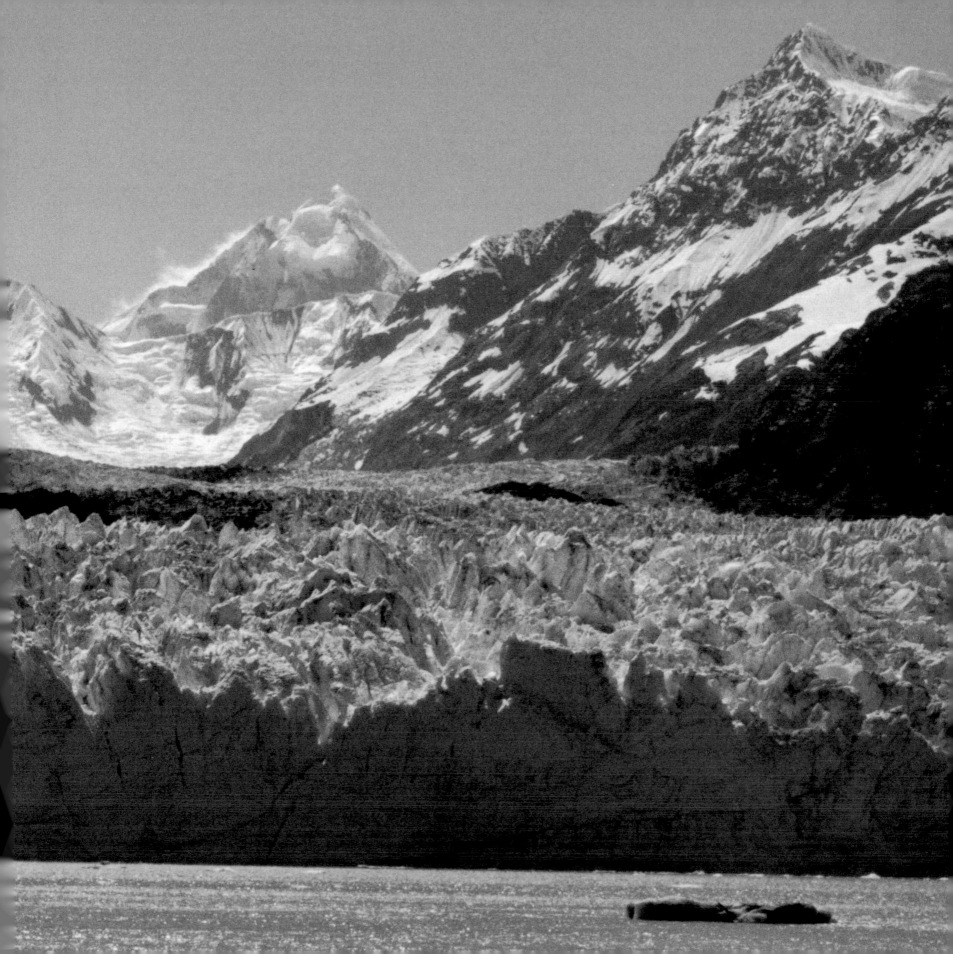

III

Abstractions in Nature

THE PHOTOGRAPHS in this section were the most enjoyable to shoot and share. I felt elated that I could see something that was my own discovery. I could see the potential of a beautiful photograph. The locations range from Florida to our little lake in the country, to a river in Colorado and on to the Atacama region in Chile. Even Niagara Falls becomes something else in this chapter.

Before you look at the titles of the pictures, try to distinguish what it is you are seeing. Before you venture an answer, just look at the forms and the colors on the page and revel in their artistry. It is the artist in the hand of Mother Nature alone. You will see rhythms and forms and abstractions that you might see in a painting by an Impressionist painter, but nature got there first—with her light and her breeze. By focusing on the colors and forms and expanding the size of the image, everything in the picture changes and becomes abstract in form.

Many of the images are reflections on water. In most of the world, water symbolizes abundance, good fortune, and very good vibrations as in the Oriental concept of Feng Shui. Everyone feels better at the waterside because of the light, air, and water—essentials of our well-being.

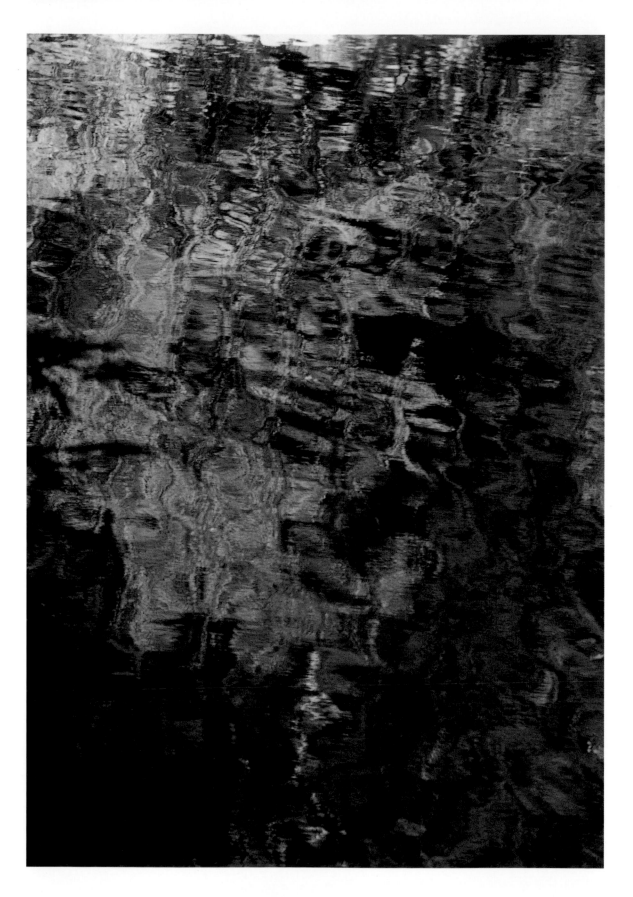

LEFT
Abstraction I,
New York, October 2000

———

OPPOSITE TOP
Tropical Reflection,
Palm Beach, 1999

———

OPPOSITE BOTTOM
Abstraction II,
New York, October 2000

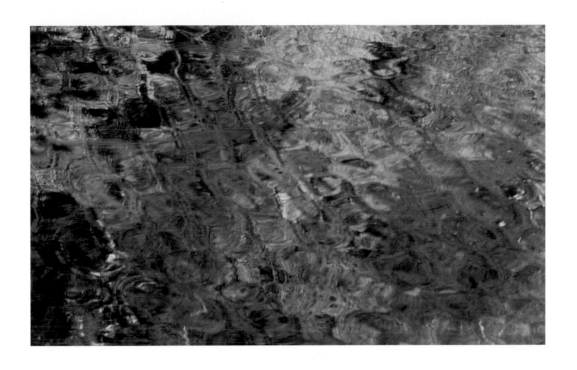

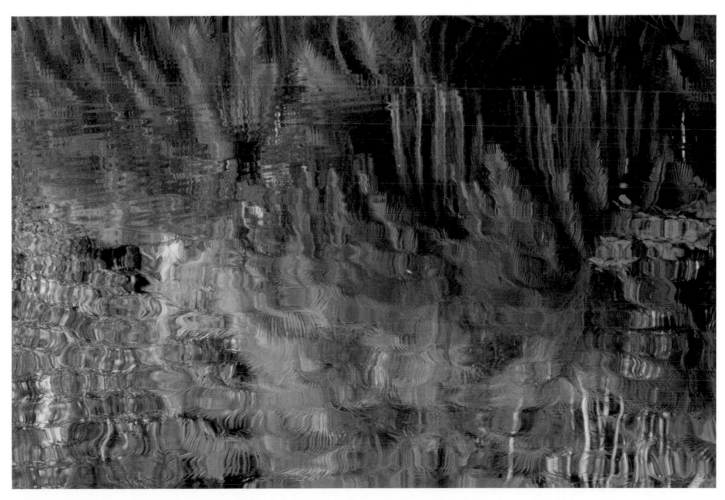

BELOW

Autumn Reflection, Fahnestock, New York, 1996

———

RIGHT

Square Autumn Reflections, Fahnestock, 1998

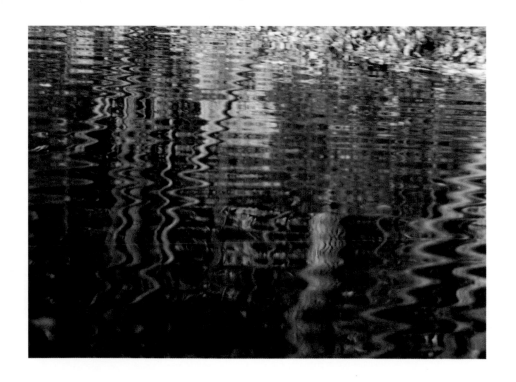

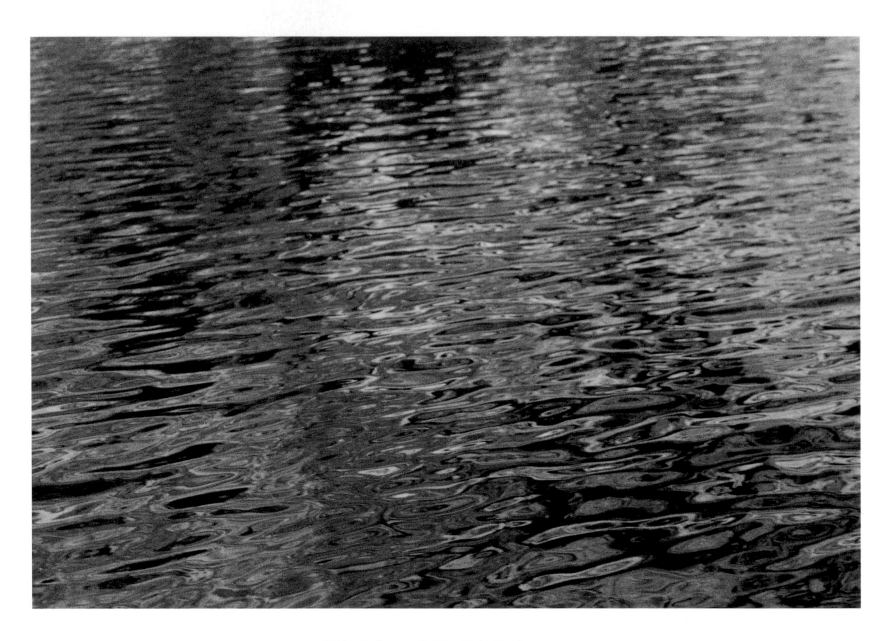

Golden Reflections II, New York, October 1999

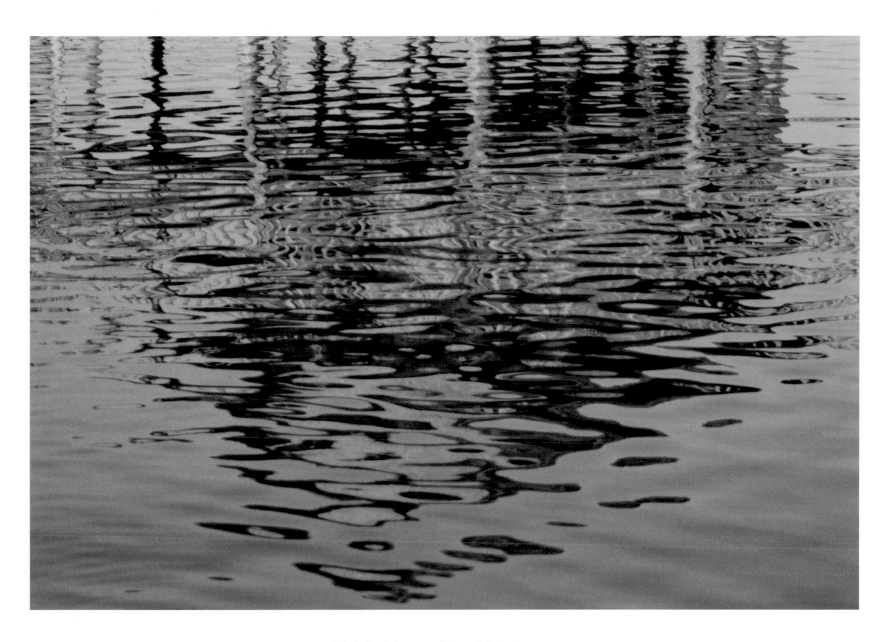

Inlé Lake, Myanmar (Burma), March 1998

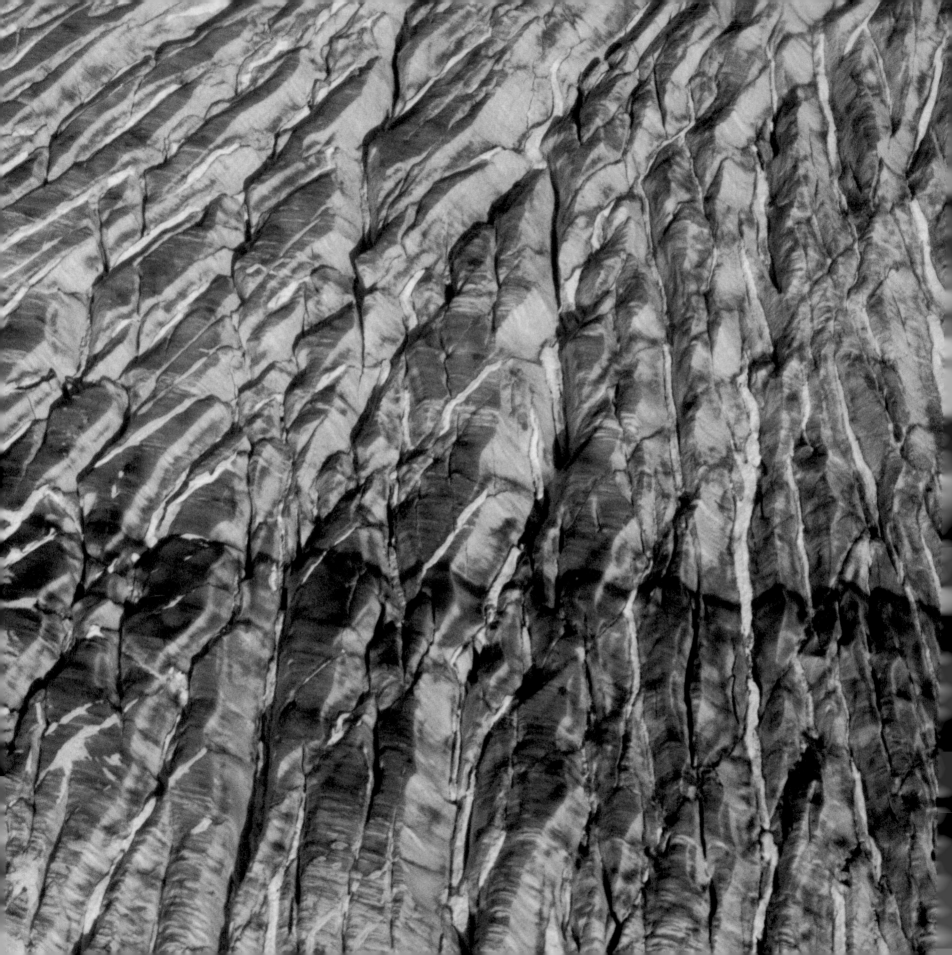

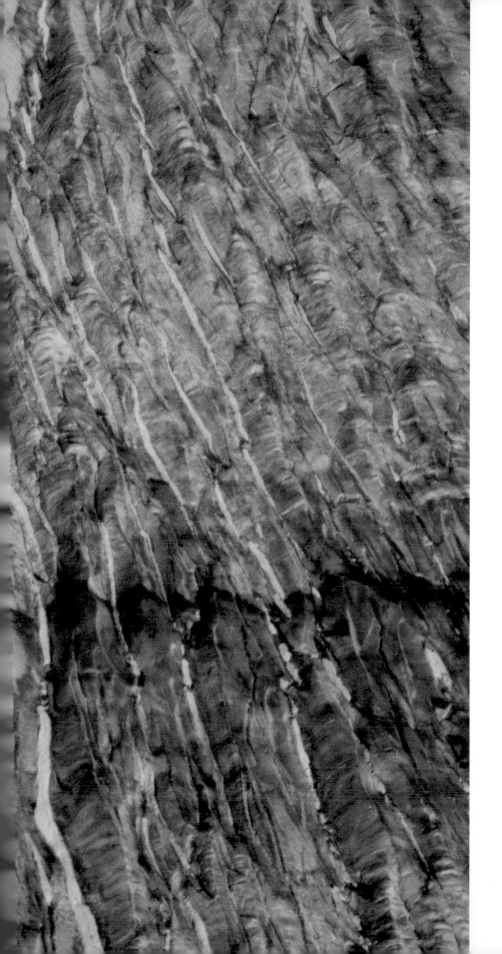

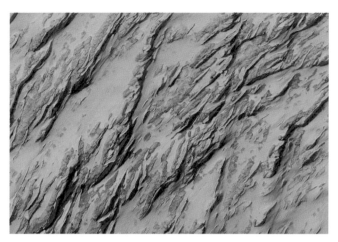

LEFT

Mendenhall Glacier II,
Alaska, June 1998

———

ABOVE

Mendenhall Glacier III,
Alaska, June 1998

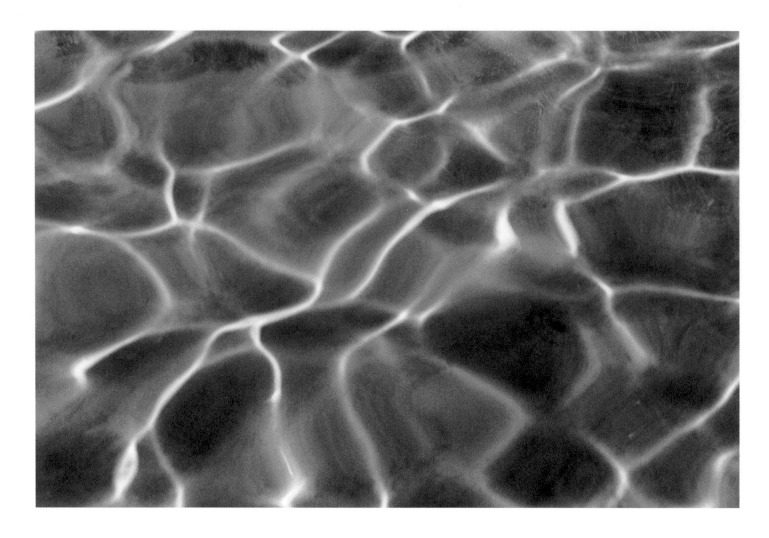

ABOVE

Abstract Water, Aspen, 1997

———

OPPOSITE

Mid-Day Reflections, Aspen, Summer 1999

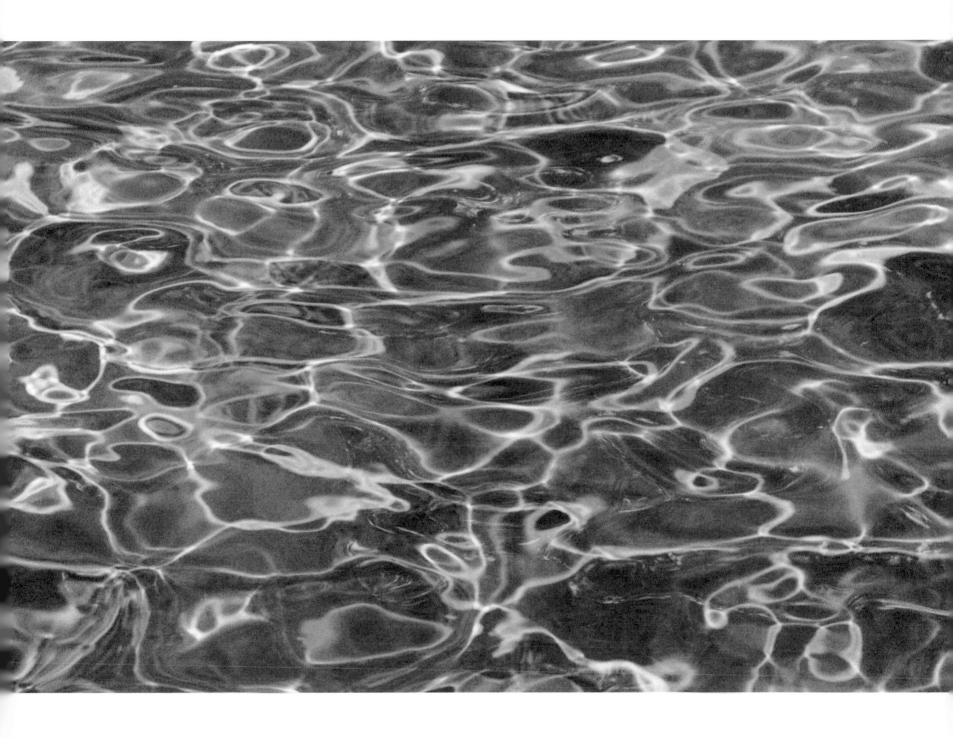

OVERLEAF

Impressionist Water V, June 1998

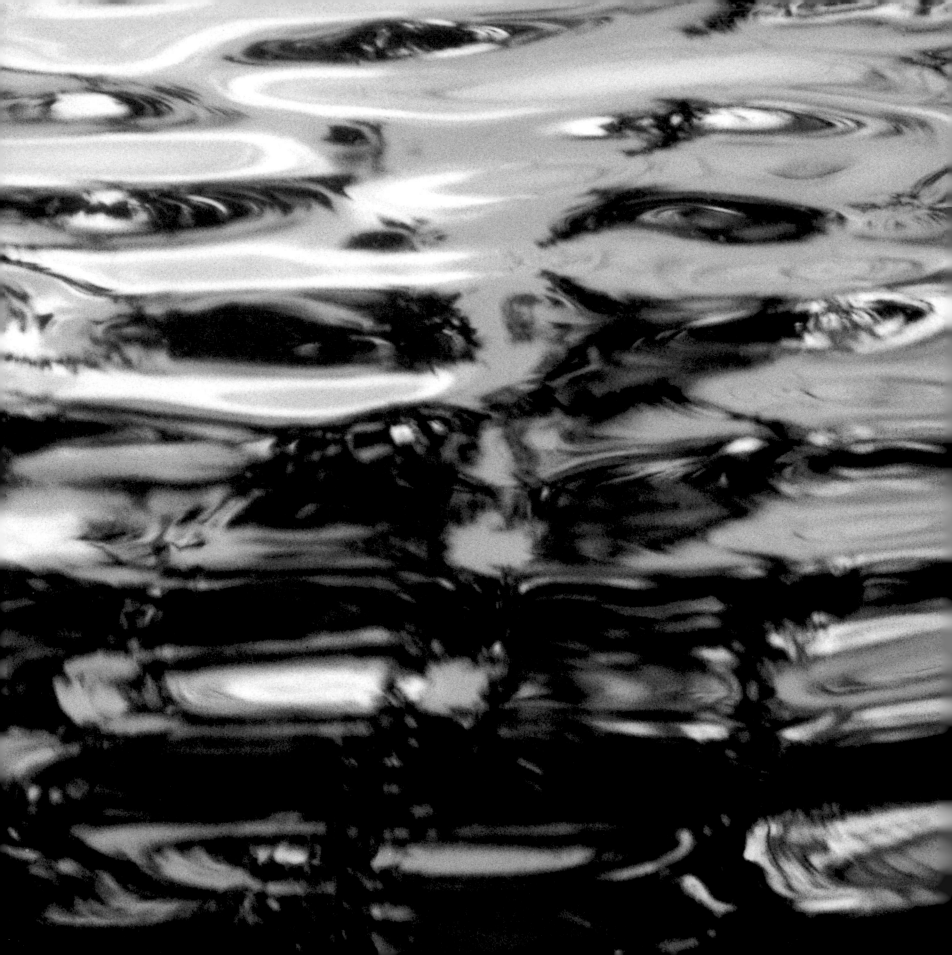

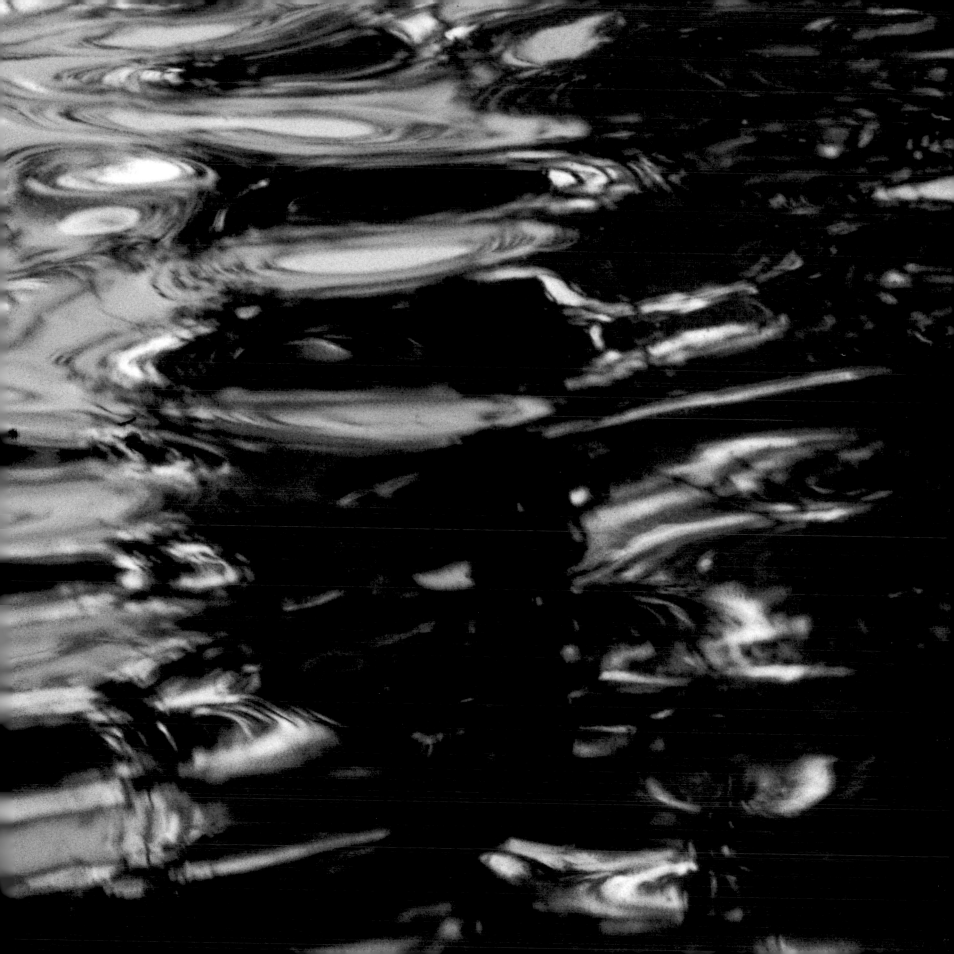

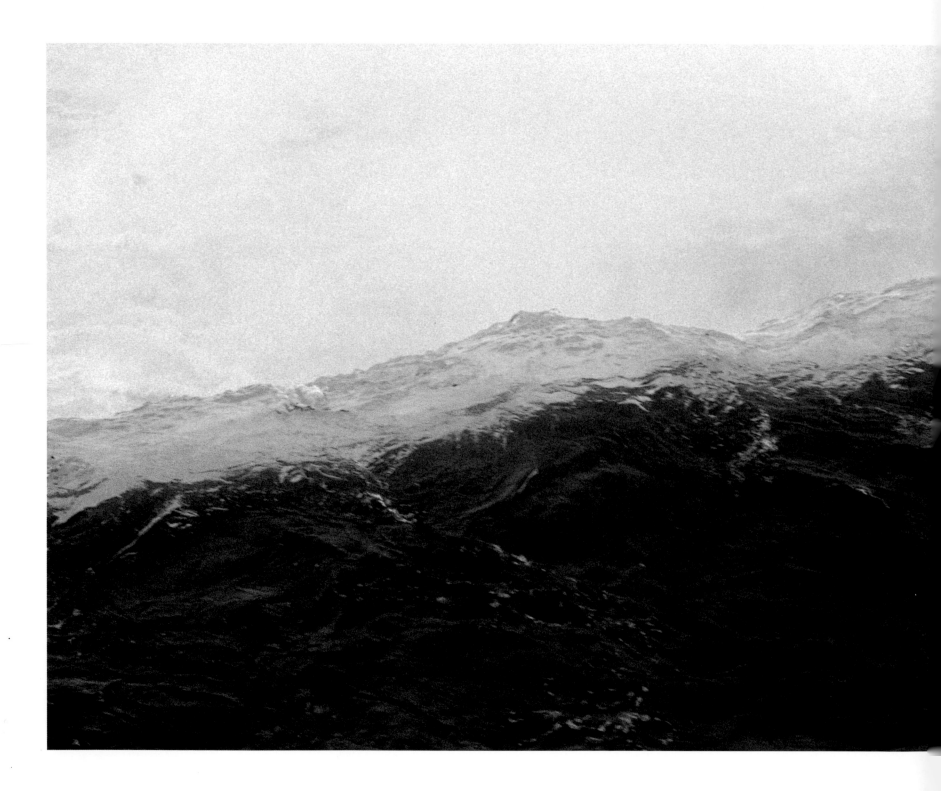

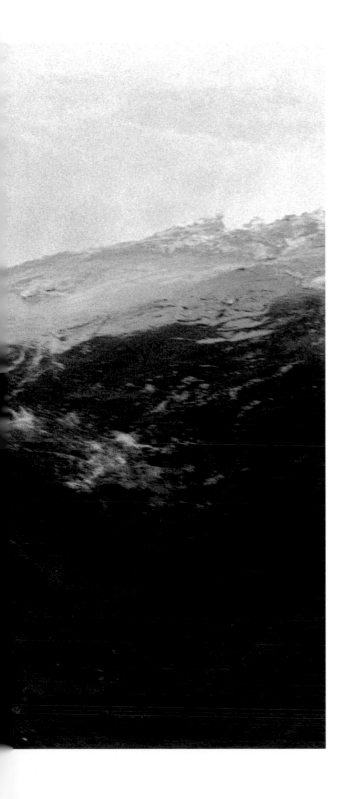

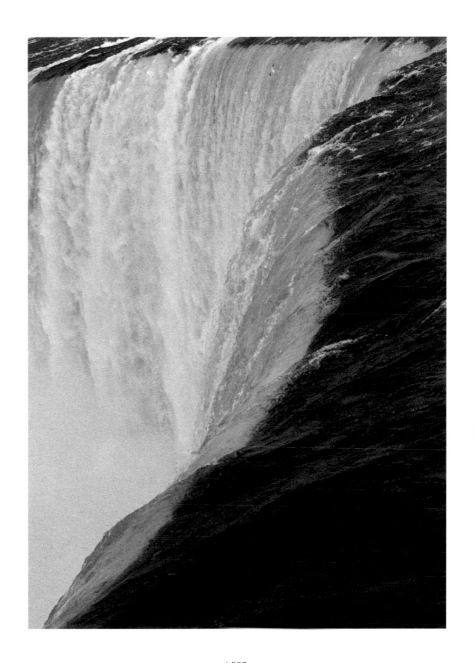

LEFT

Blue Force, Niagara Falls, October 2001

———

ABOVE

Abstract Niagara, October 2001

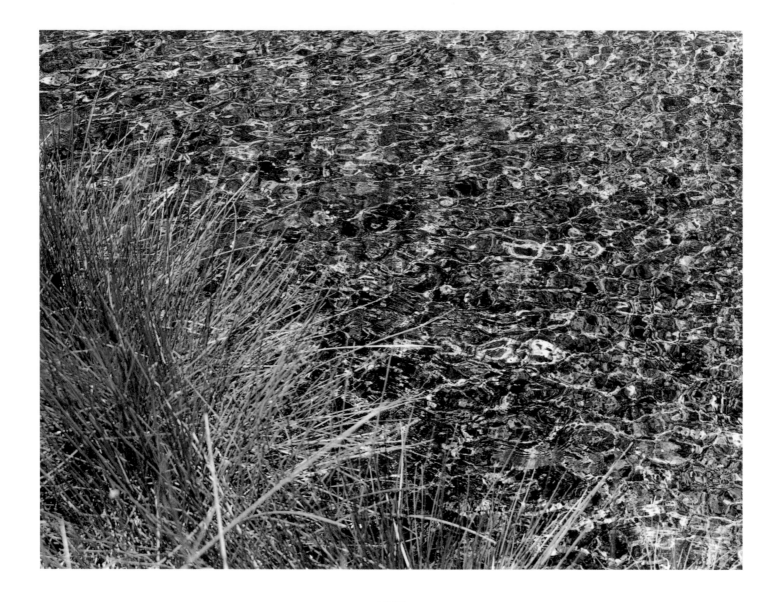

Hot Springs Swimming Hole, The Atacama, Chile, November 2000

———

Abstract Lake Titicaca, November 2000

———

Roaring Fork River Pebbles, Aspen, Summer 1998

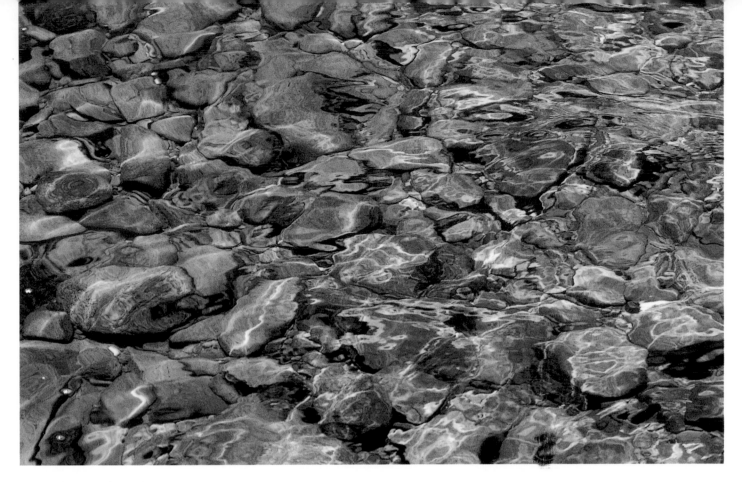

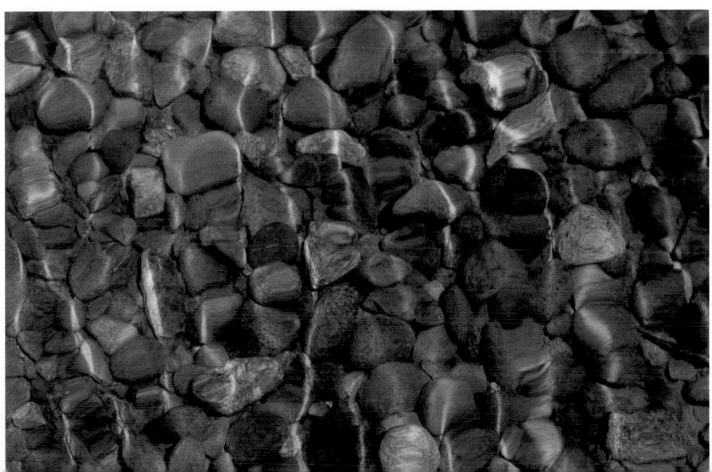

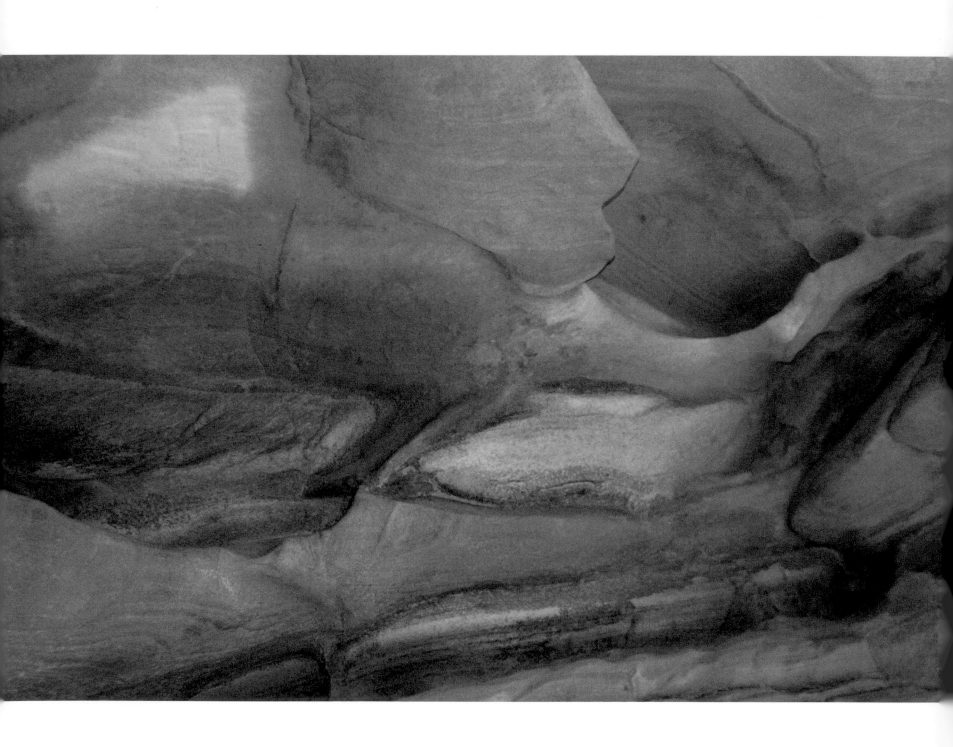

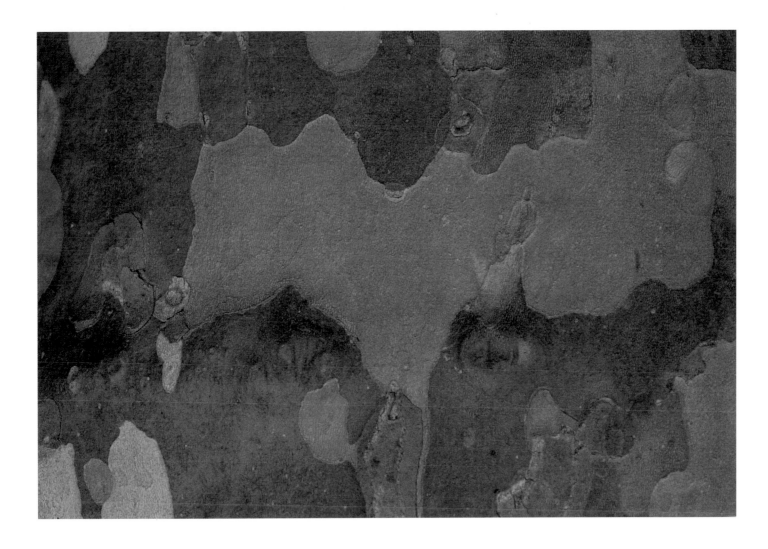

OPPOSITE
Abstract Rock Formations,
San Sebastian, Spain, October 1999

———

ABOVE
Bark of Plane Tree II,
Provence, France, May 1994

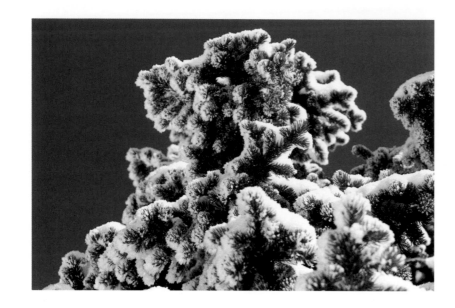

ABOVE

Hoarfrost Spruce, Richmond Ridge, Aspen, February 1997

———

RIGHT

Tree and Sky Reflection Pool, Colorado, July 2001

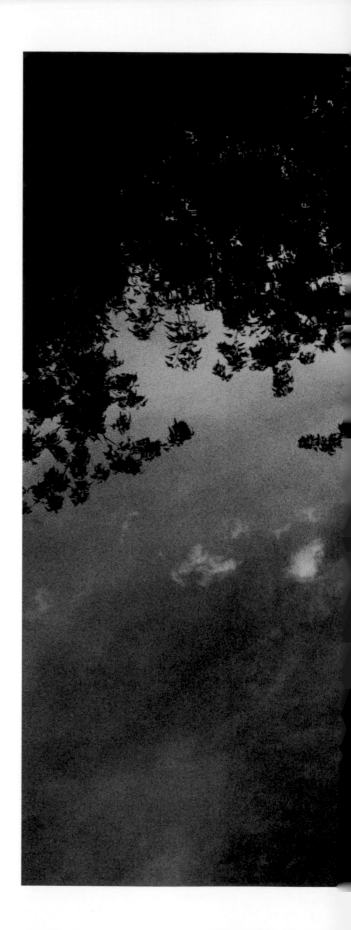

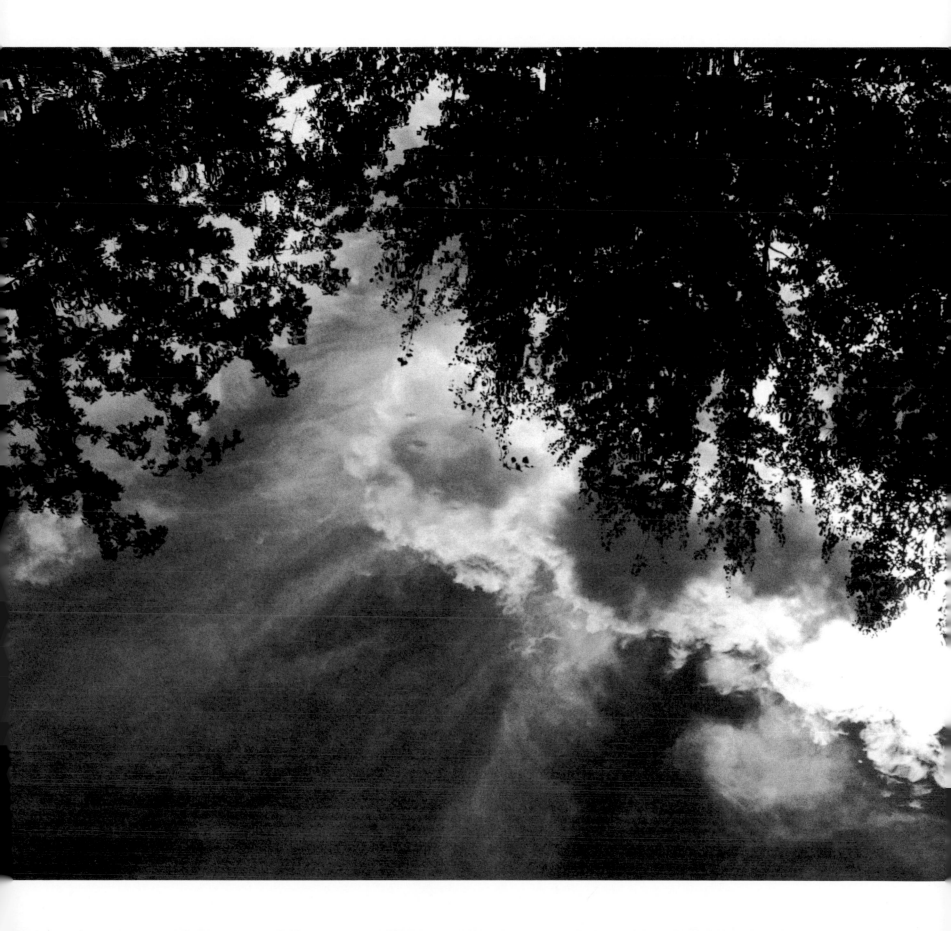

IV

Leaves, Flowers, and Light

SINCE CHILDHOOD, flowers have been a special passion of mine, both for their complex beauty and for their scent. Of all the groups of photographs in the book, this one is the most direct in interpretation. What makes this group powerful is the way light enhances the design of the forms and the colors. In no case was there any artificial light—only sunshine and the good luck to be there at the right time with a reliable camera.

These photographs require no words. They speak for themselves.

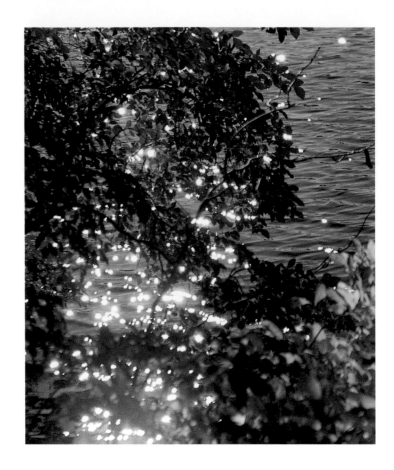

ABOVE

Sunsparkle II, New York State, October 1994

———

RIGHT

Weeping Cutleaf Japanese Maple, New York City, June 2001

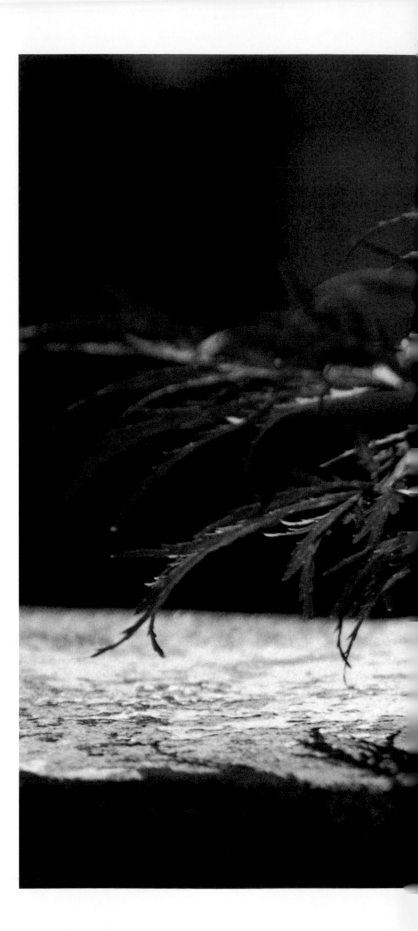

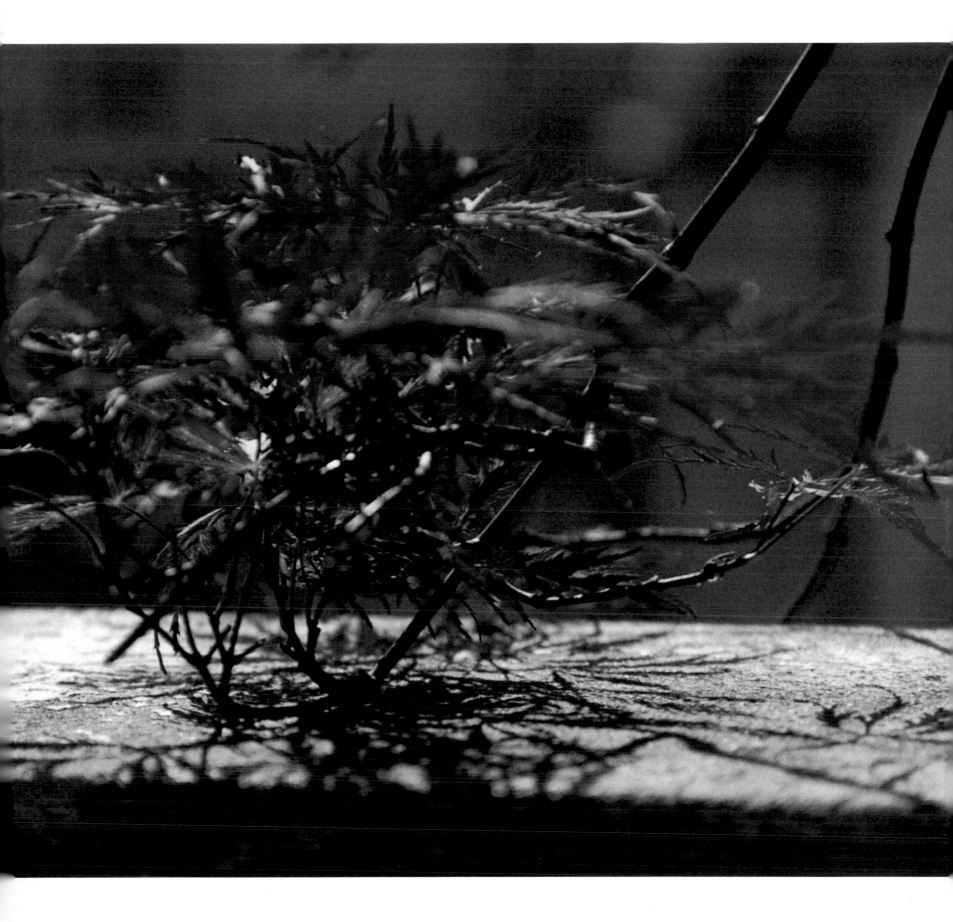

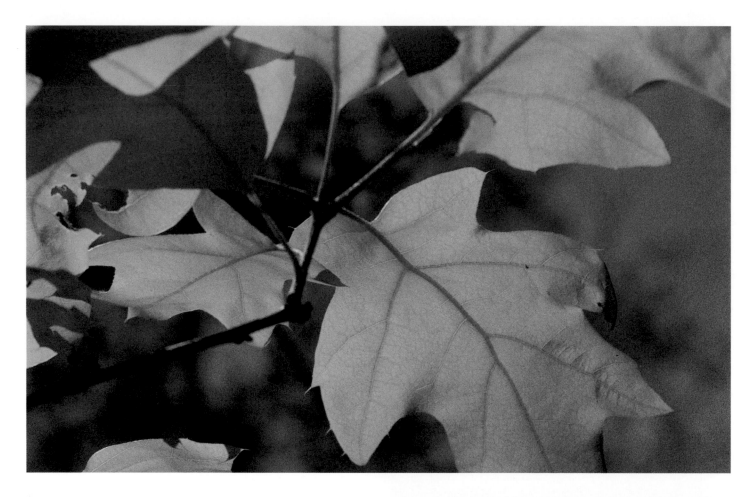

ABOVE

Green and Blue, Fahnestock, May 2000

———

RIGHT

Glorious Gold, Fahnestock, October 1999

———

OPPOSITE

Bearded in Bariloche, Argentina, March 1999

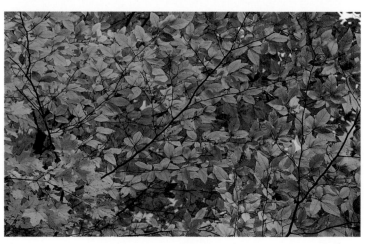

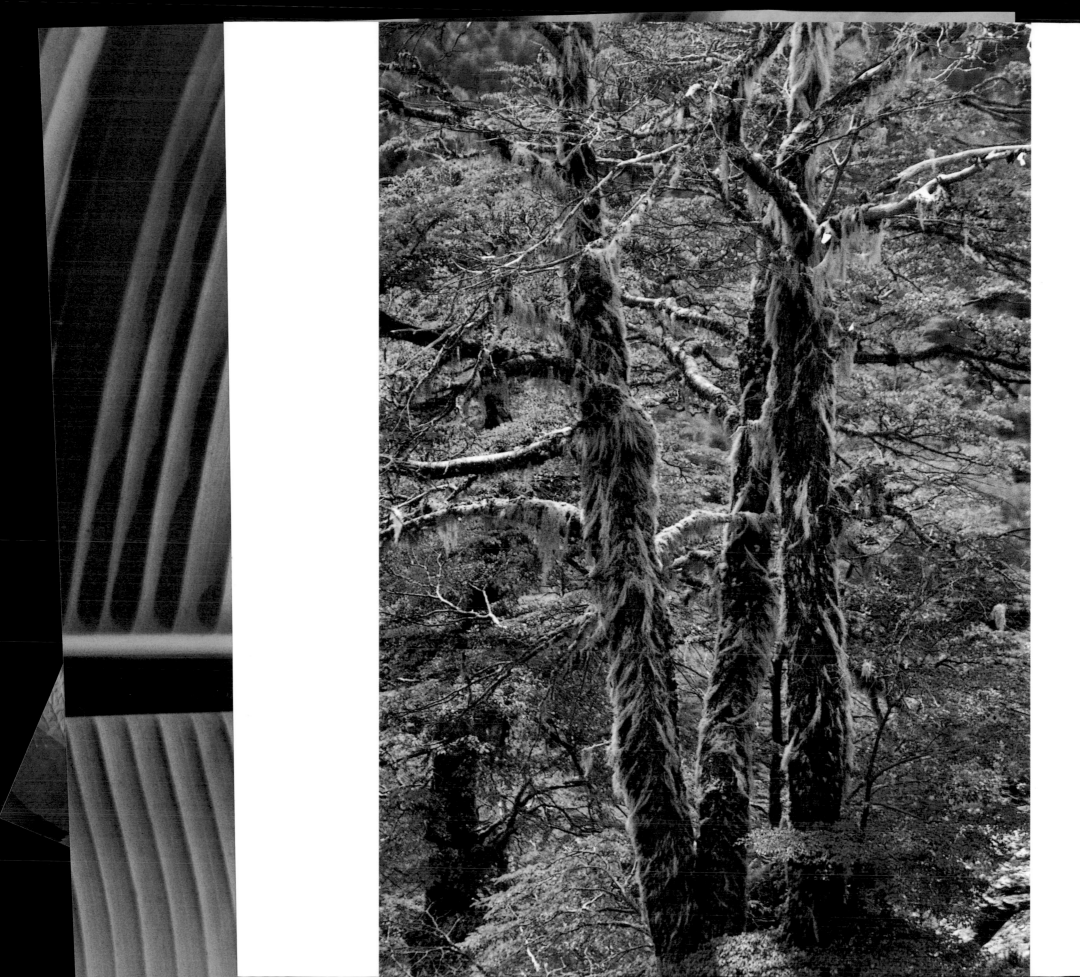

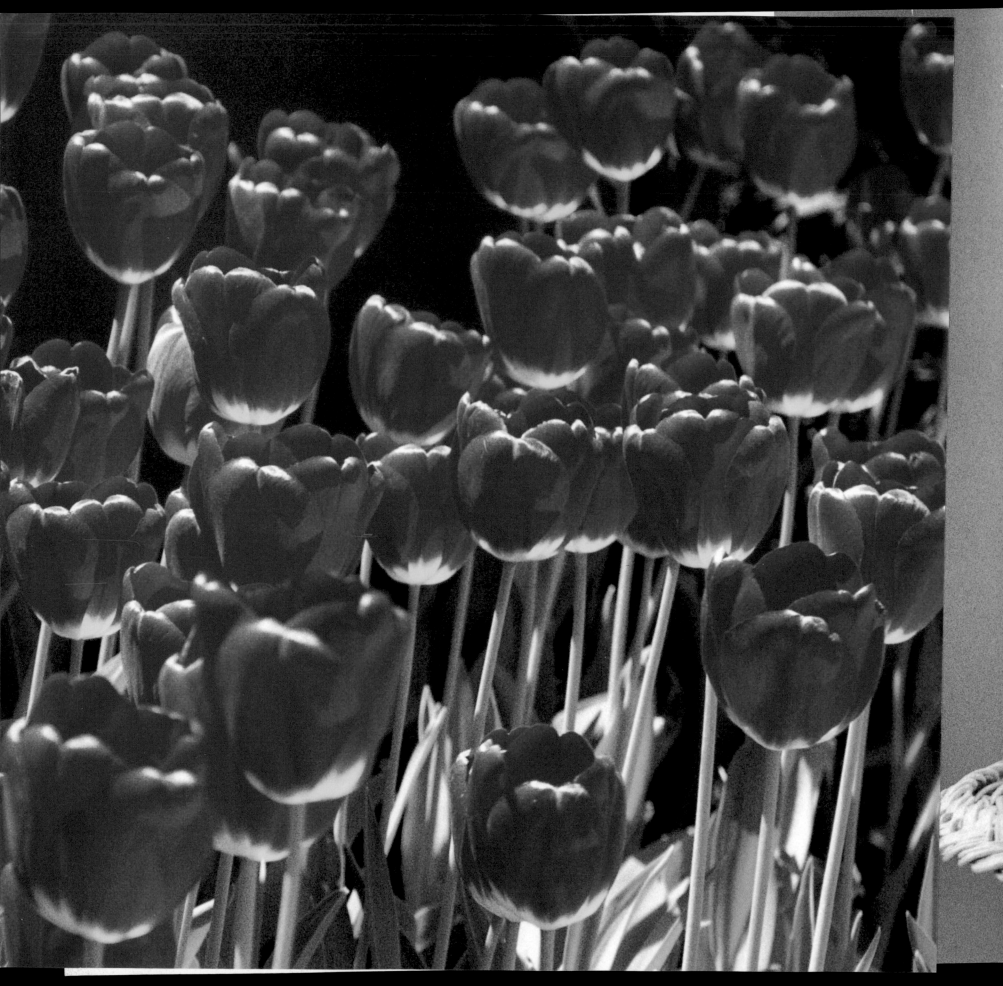

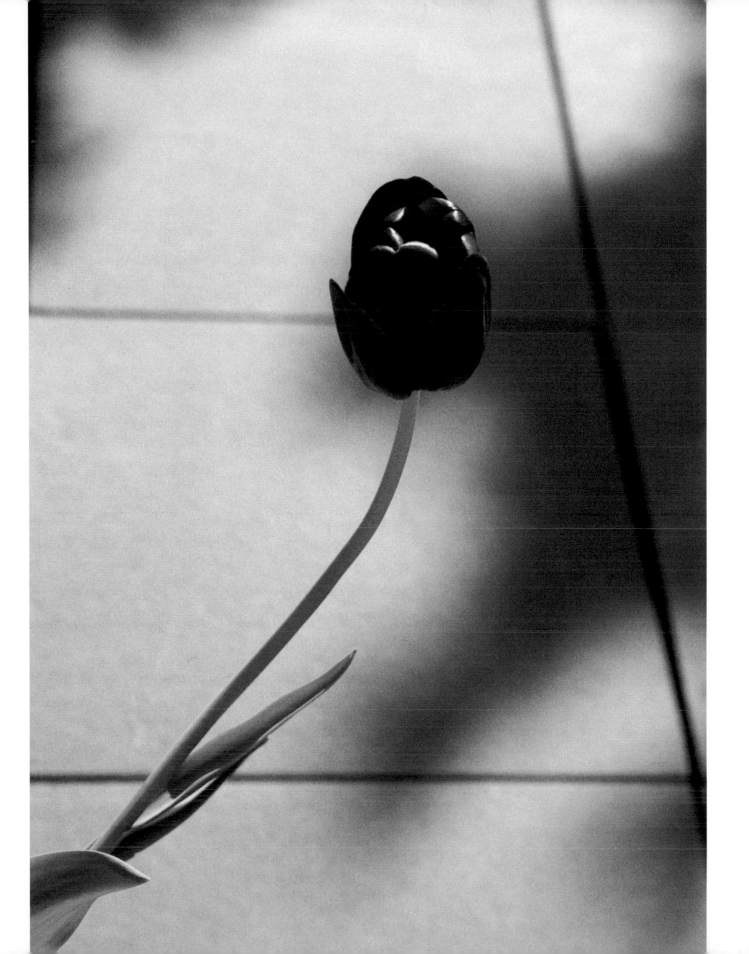

LEFT
Delphiniums Reflected,
New York City, July 200

OPPOSITE
Delphiniums at Sunset,
July 2001

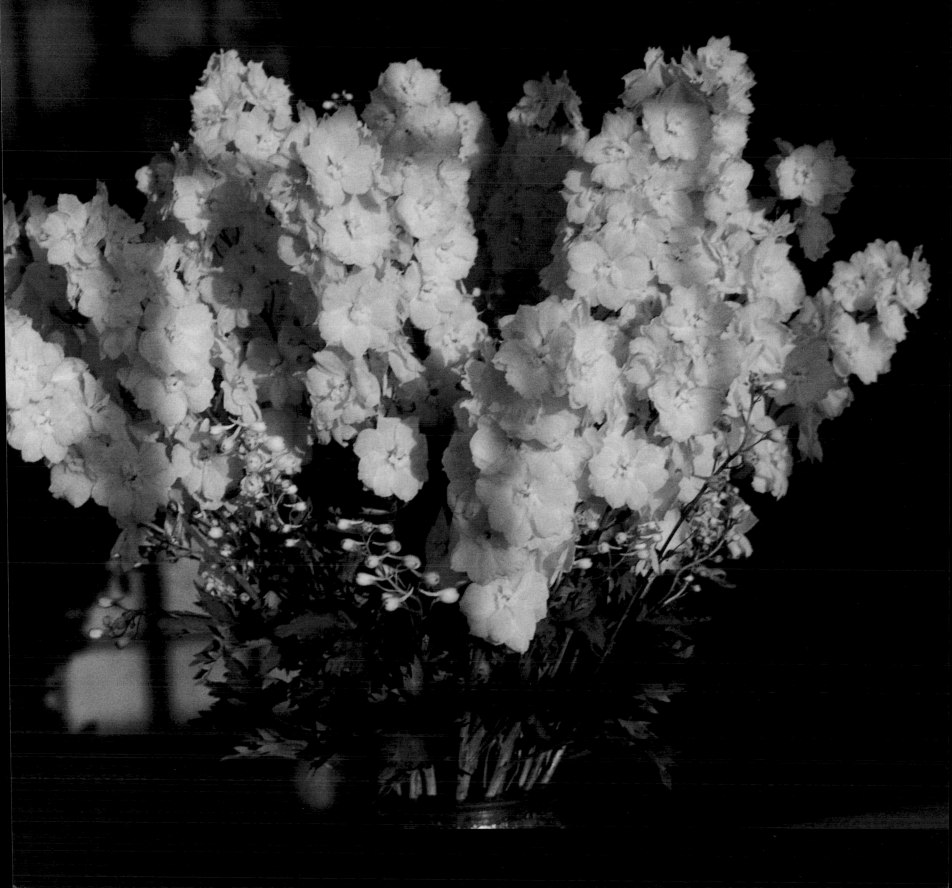

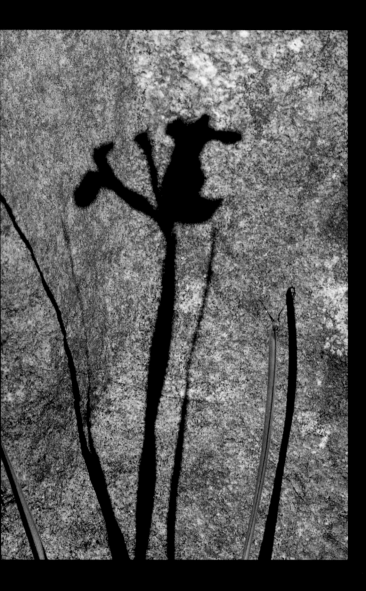

Iris Shadow, New York State, June 2001

———

Cut Leaf Japanese Red Maple in Early Spring,
New York City, 2000

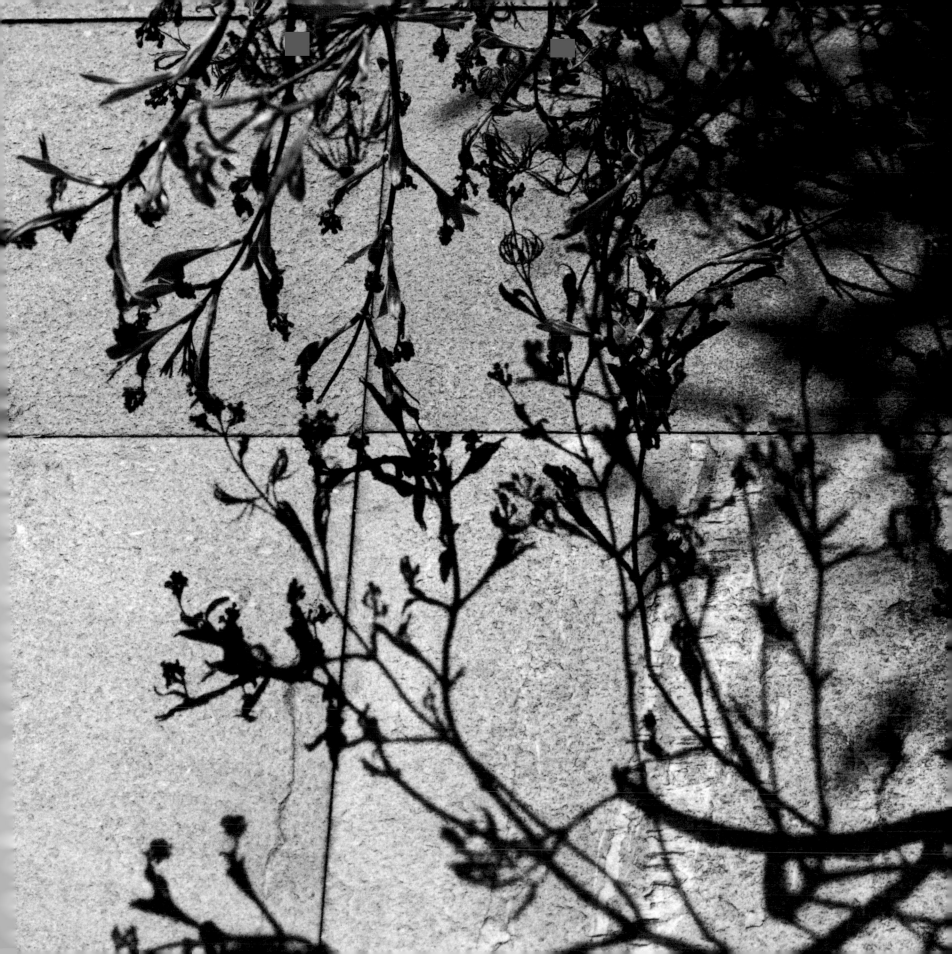

V

The Human Touch

NEARLY ONE HUNDRED YEARS AGO, skillful craftsmen made straw sunshades, a gate in Havana, beautifully patterned lace. Rhythms are created in their work, patterns refracted through glass. Shadows themselves form patterns that have a beauty of their own when seen at close range.

In "Ice Storm" it is easy to discern icicles dropping from the arabesques, but what is more subtle are the two-sided ice edges that follow the form of the design, emphasizing the curves and shapes and adding great drama to the senses. You can almost feel the cold.

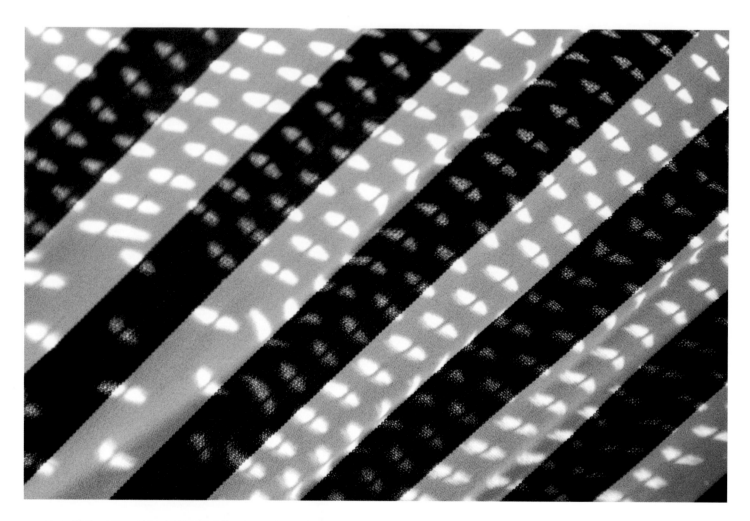

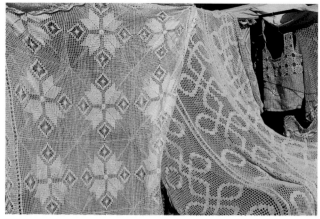

ABOVE
Wicker Shadows on Chair,
Hot Springs, West Virginia,
June 2001

———

LEFT
Lace for Sale, Mexico, 1998

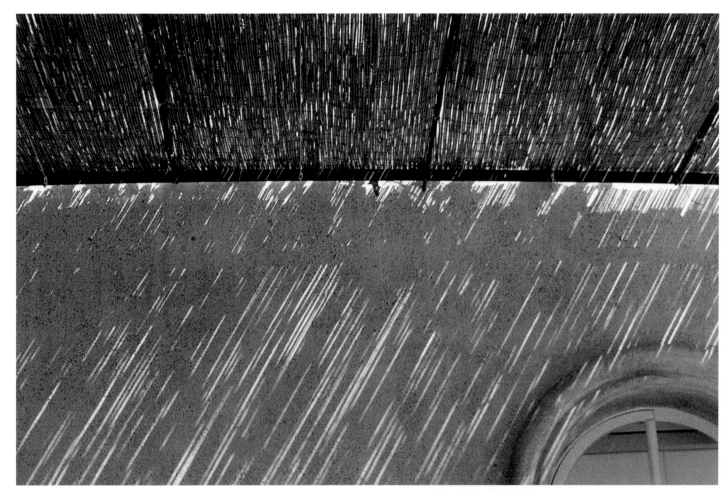

ABOVE

Sun Showers, France, September 1999

RIGHT

Lunch, Cadaquès, Spain, October 1999

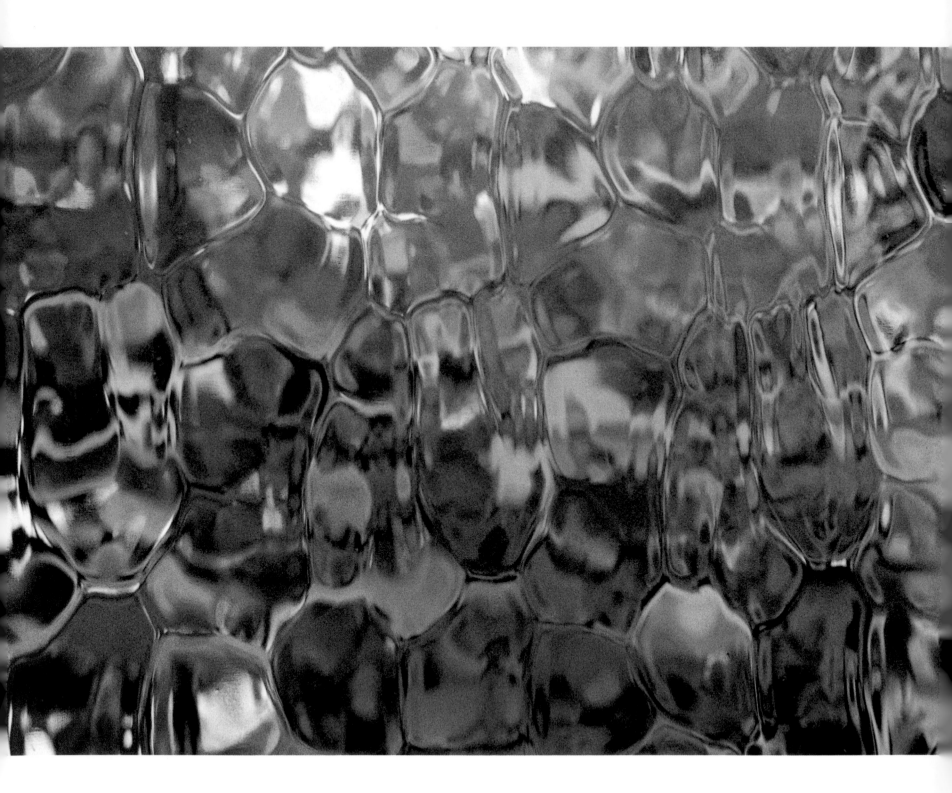

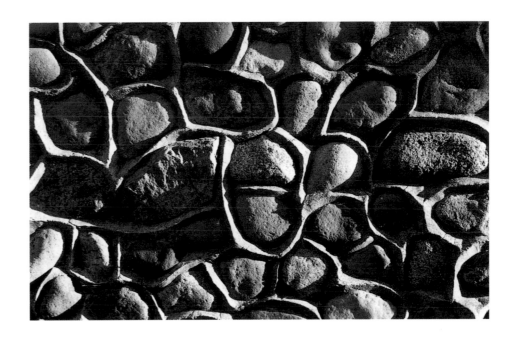

OPPOSITE
Glass Reflections,
South America, November 2000

———

ABOVE RIGHT
Stone Wall, Porto Varas,
Chile, February 1999

———

RIGHT
A Roof in Tuscany,
August 1998

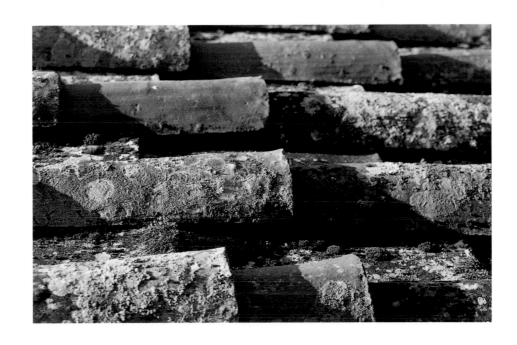

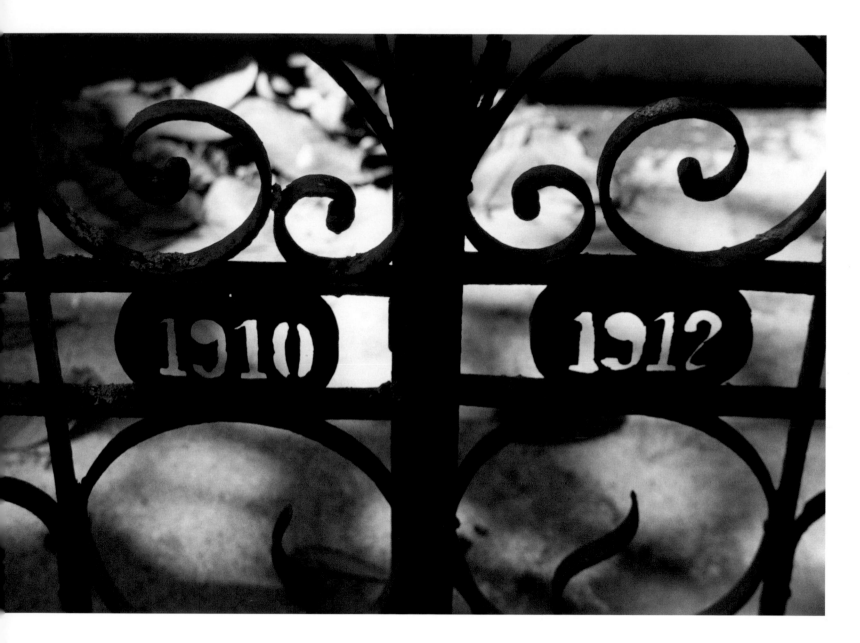

1910—1912, Havana, Cuba, 1998

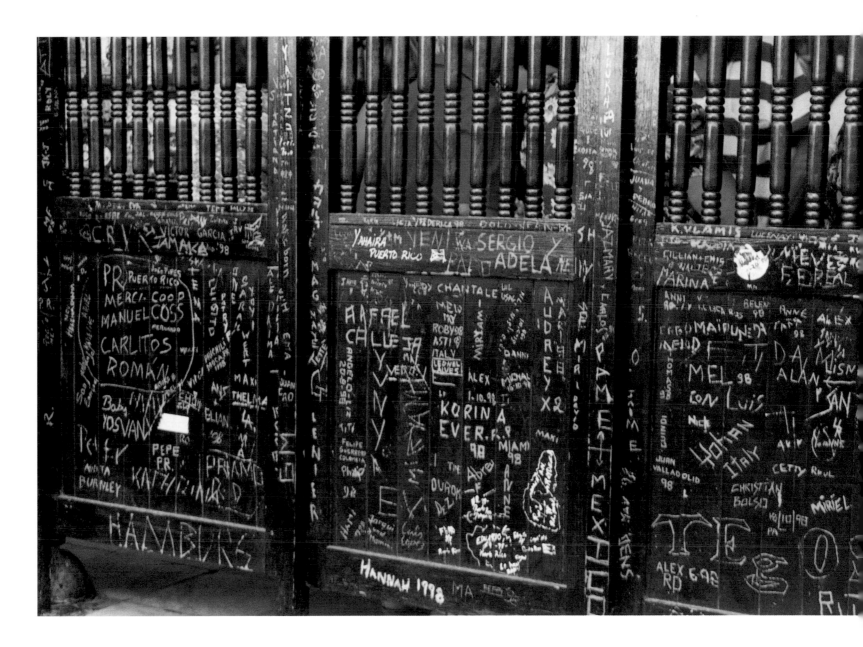

Busy Gates, Havana, 1998

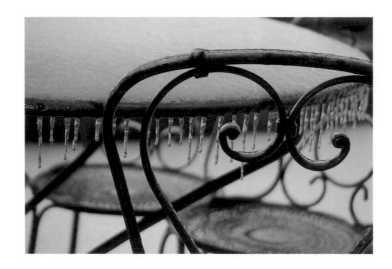

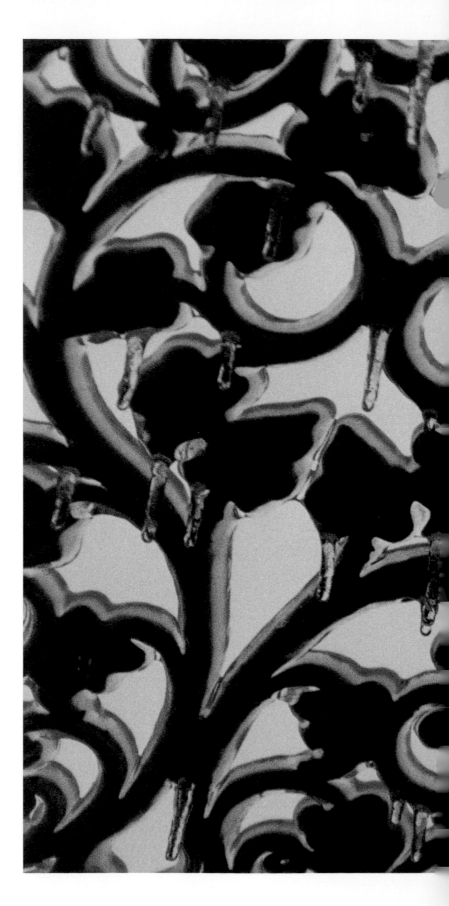

ABOVE

Imagine the Cold, New York City, 1999

———

RIGHT

Ice Storm, New York City, 1999

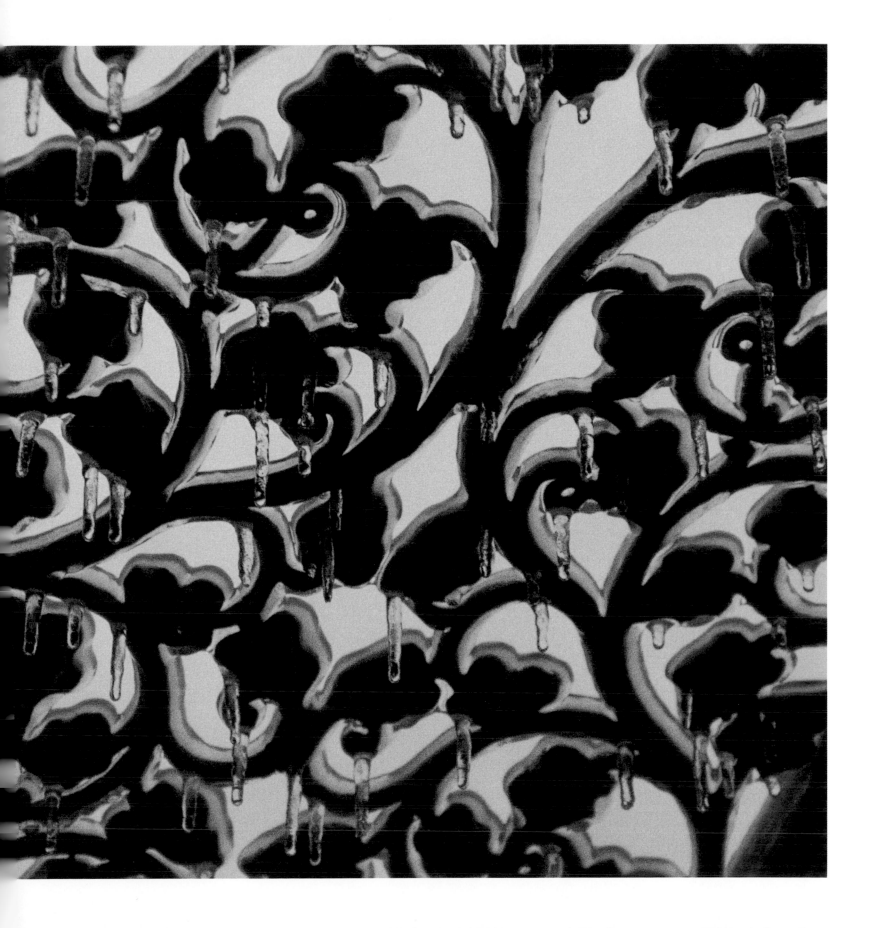

VI

The Human Presence

HUMAN CREATIVITY enhances nature in this group of photographs. Eduardo Chillida's sculpted forms reach out to capture and hold the air by the sea. The wind flowing through his work makes sounds, and the metal shapes are as much a part of the landscape as the rocks that support them. The water moving between these fluid and solid forms connects them constantly.

In this group, there are walls and boats and even some people who in themselves become part of a beautiful design along with shapes of their vessels and the colors of their clothes. Birds that nest on old pilings from an ancient abandoned dock simply occupy the stunning view of the water and the distant mountains on the horizon. Humans, on the other hand, enter the scene in a bolder, more visible way, fashioning what they need in order to control their space.

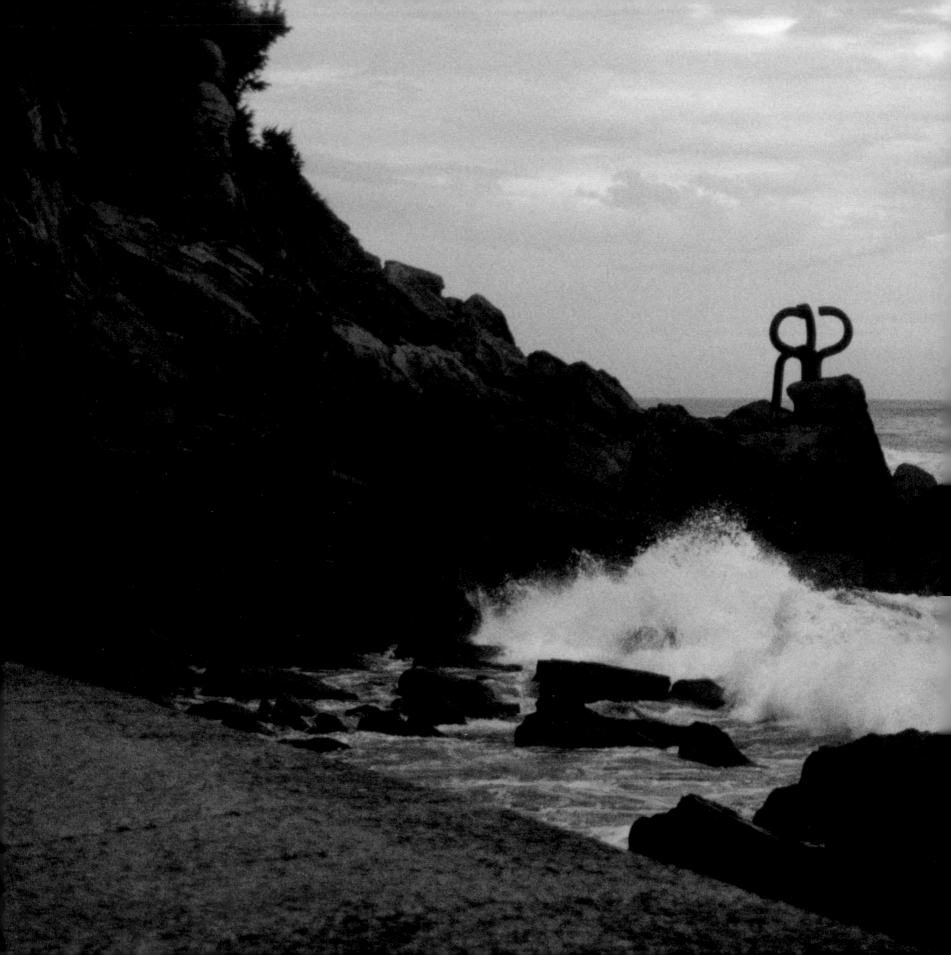

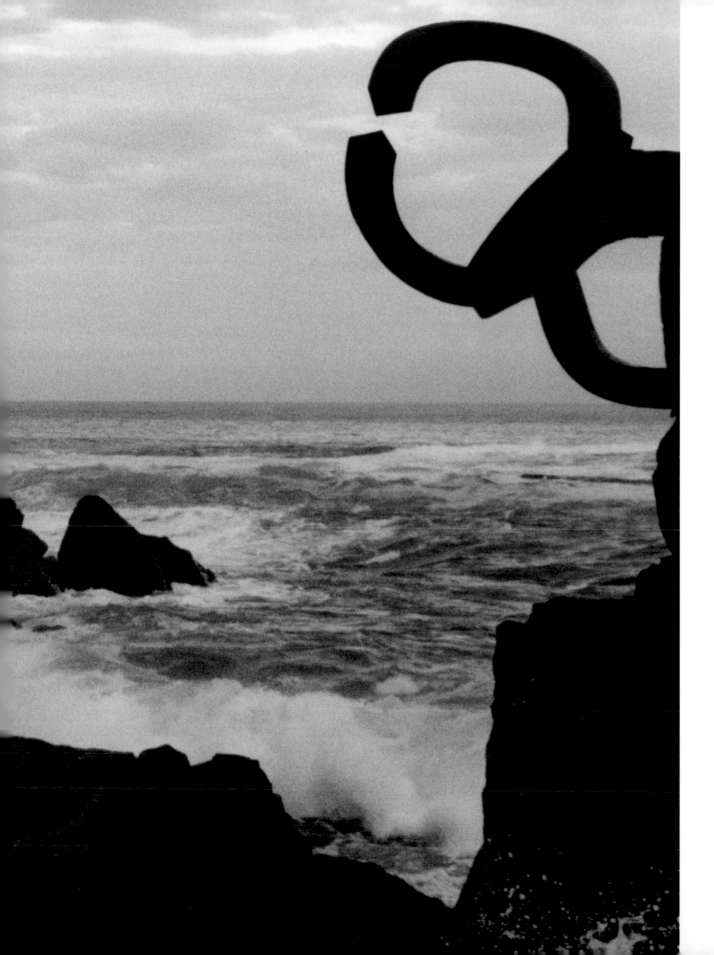

*San Sebastian Coast
with Eduardo Chillida Sculptures,
October 1999*

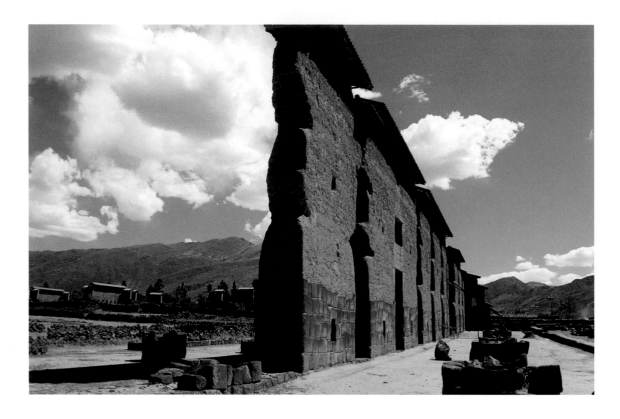

ABOVE

Inca Walls, Raqchi, Peru, November 2000

———

OPPOSITE

The Red Hat, Santa Fe, New Mexico, 1995

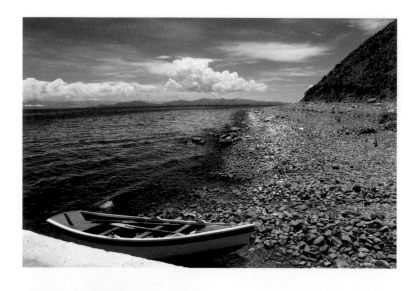

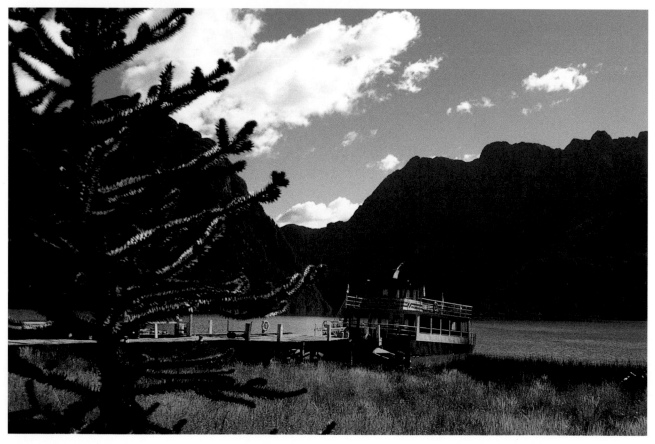

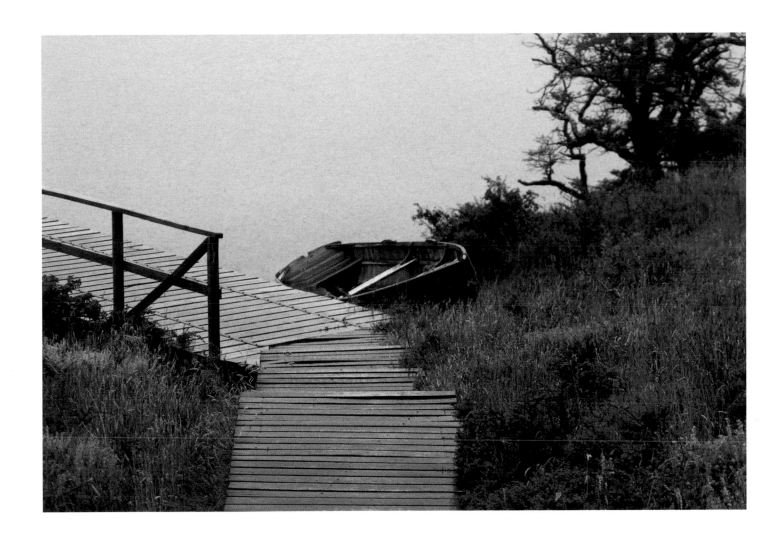

Lake Titicaca, November 2000

Andes Ferry, South America, February 1999

Explora Hotel Dock, Patagonia, Chile, February 1999

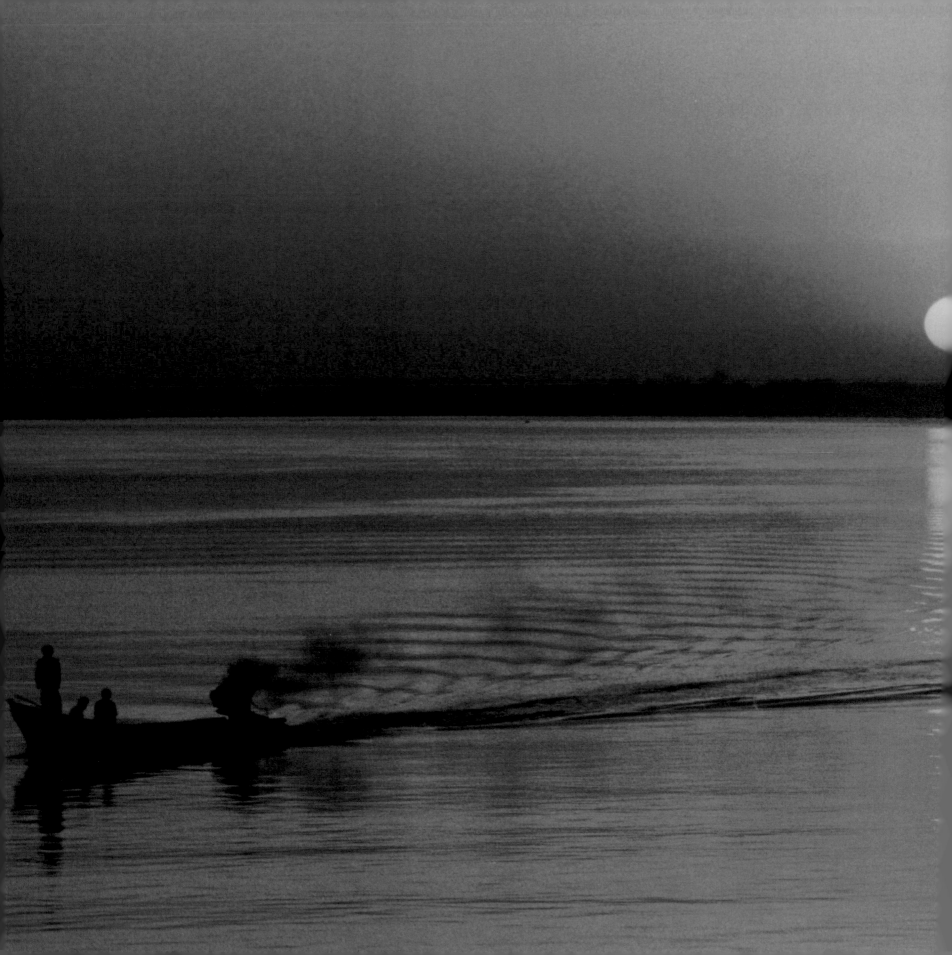

Sunset, Inlé Lake,
Myanmar, March 1998

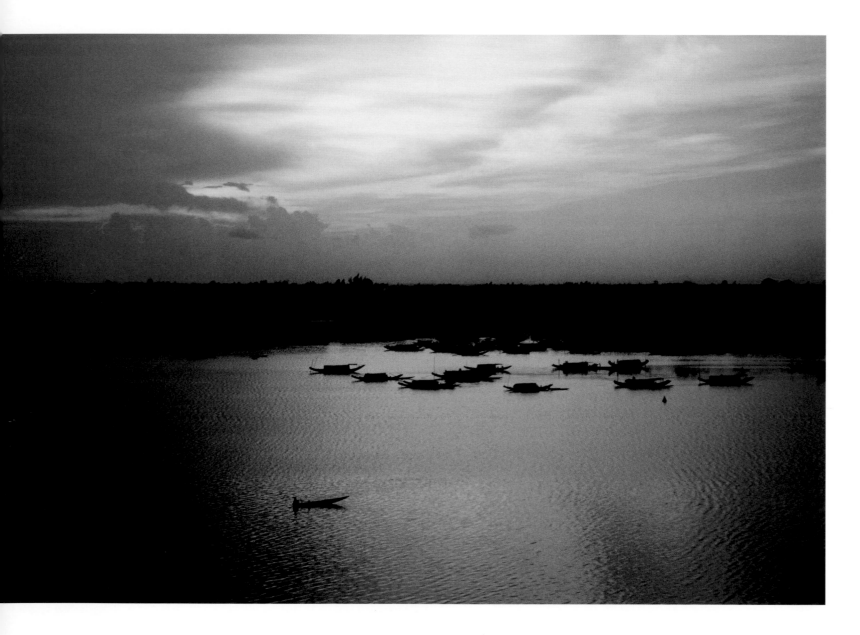

Vietnam, May 1995

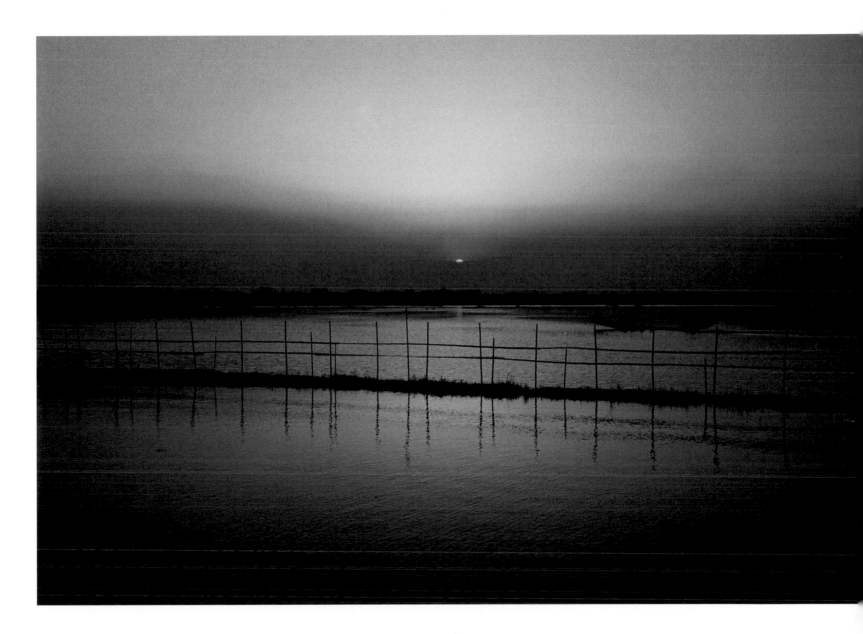

Inlé Lake, Myanmar, March 1998

108

LEFT
Rolling Hills II, Ecuador,
November 1999

———

BELOW
Hampshire Garden with Swan,
England, Summer 1998

———

OPPOSITE
Forgotten Fence,
Jackson, Wyoming, July 1998

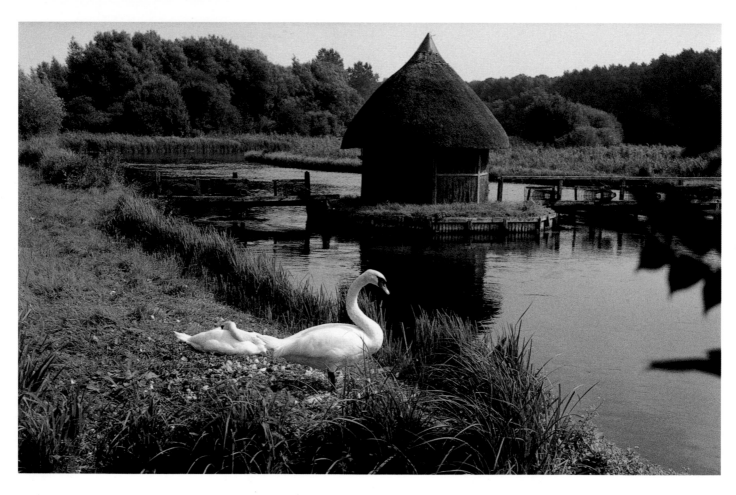

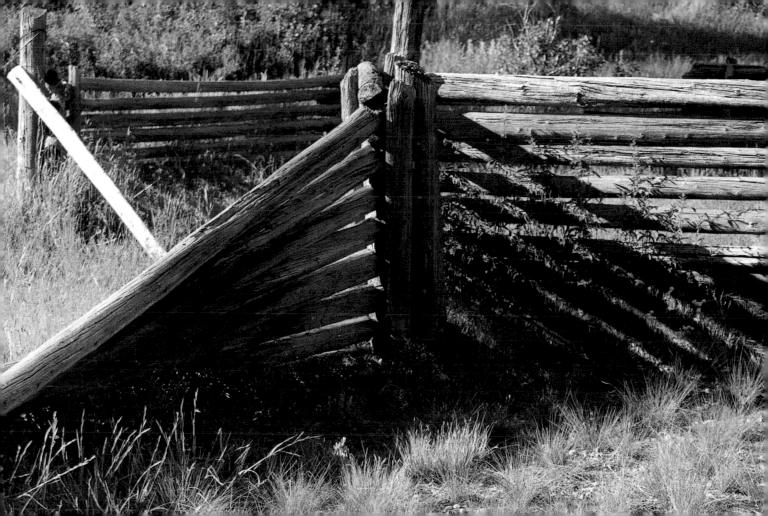

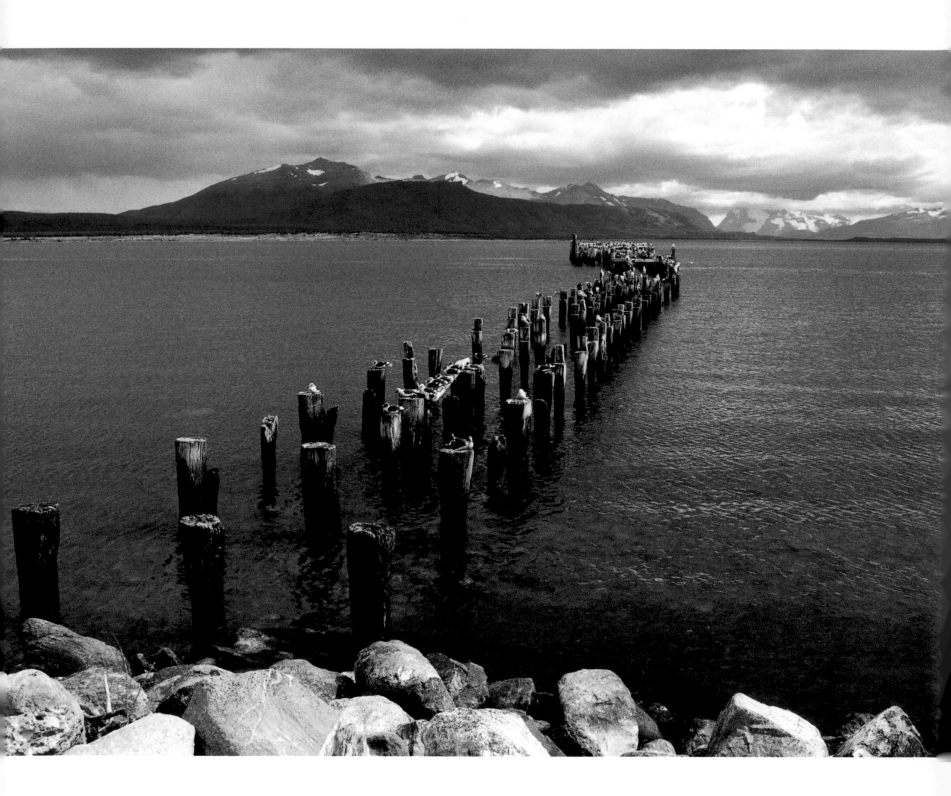

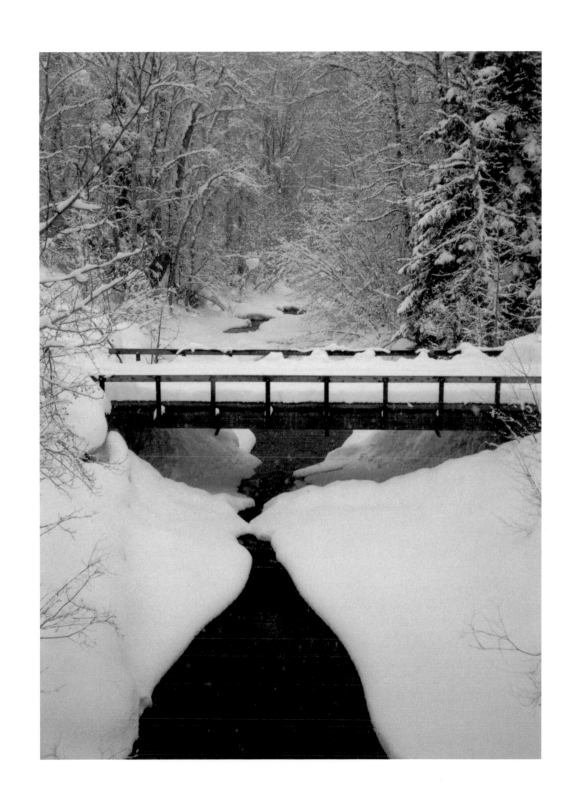

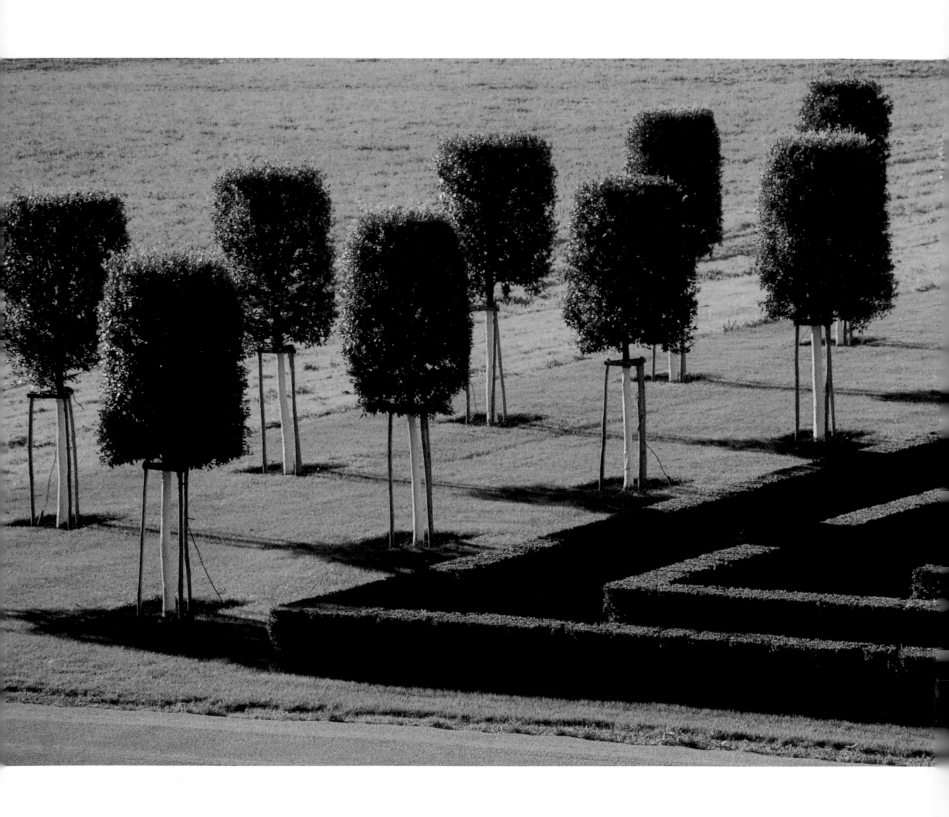

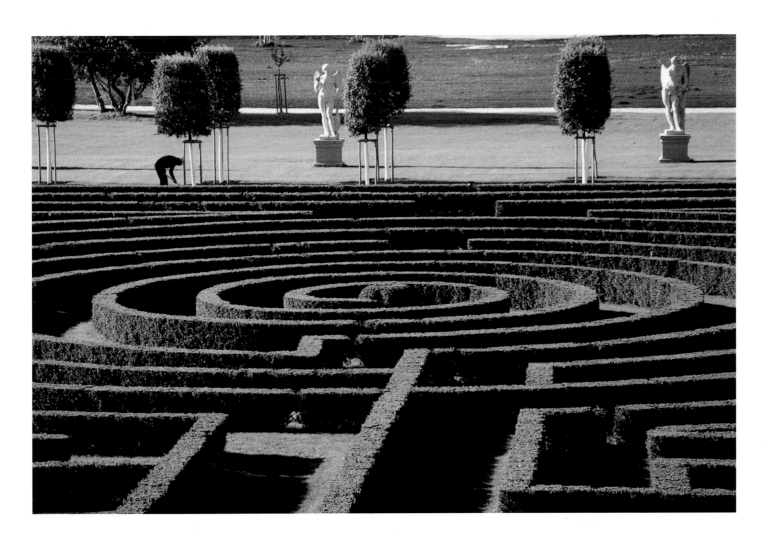

113

OPPOSITE

Geometry, Le Paradou, France, 1998

———

ABOVE

Le Paradou, France, 1998

OVERLEAF

French Hammock and Irises, June 1994

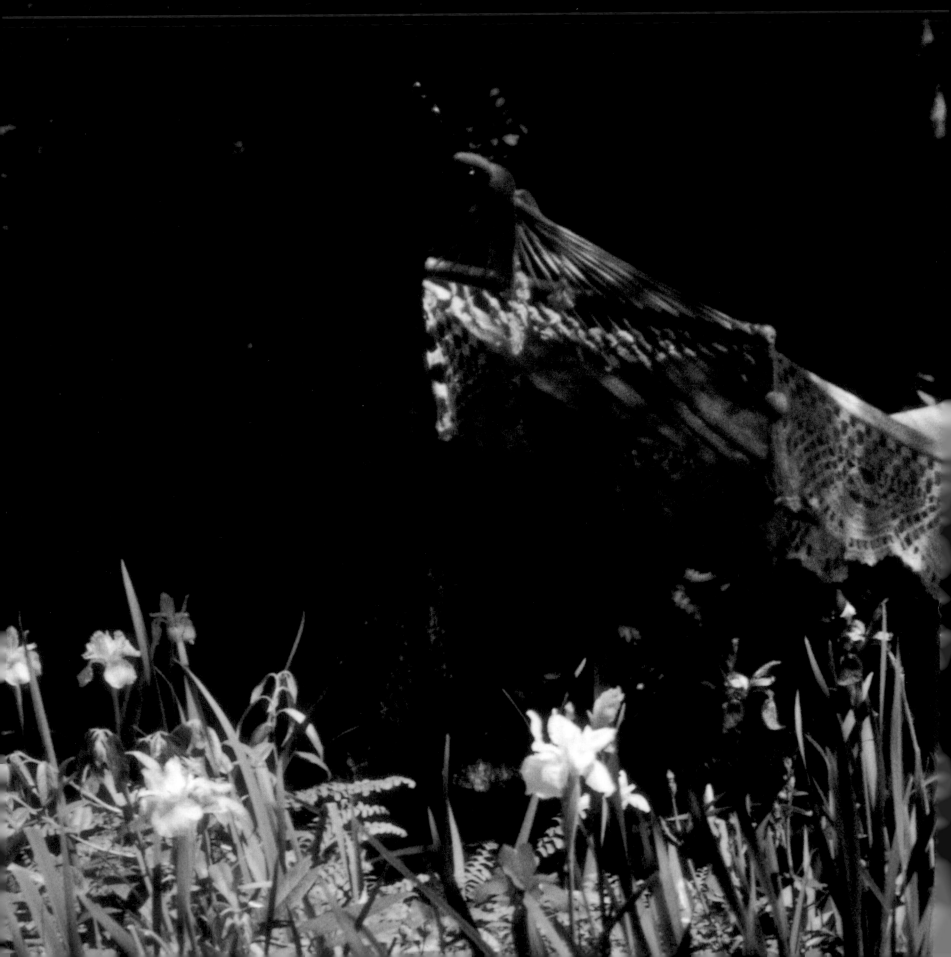

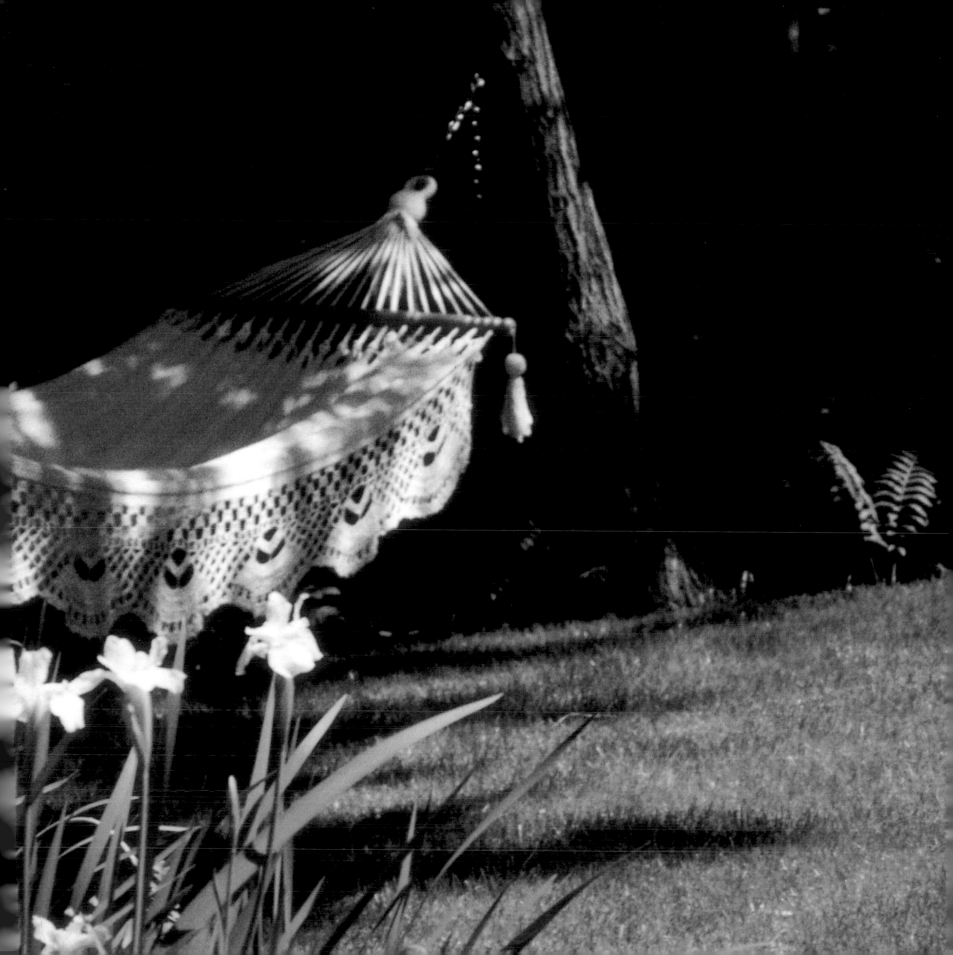

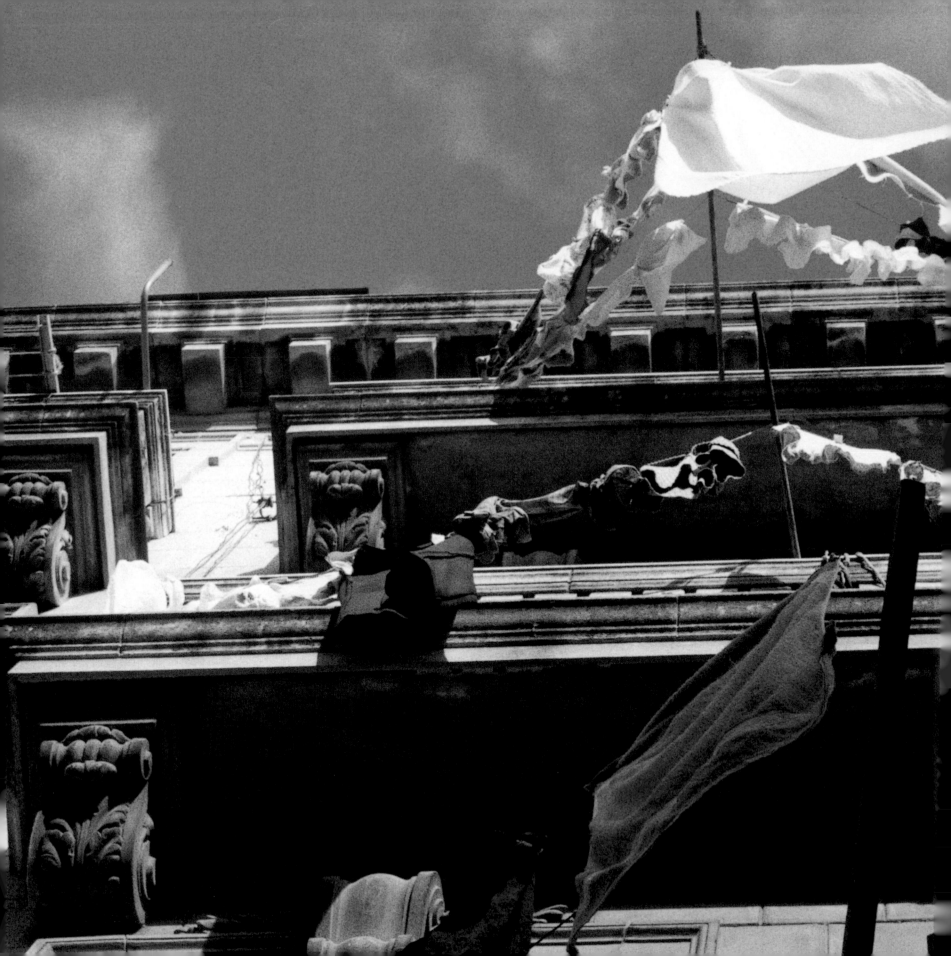

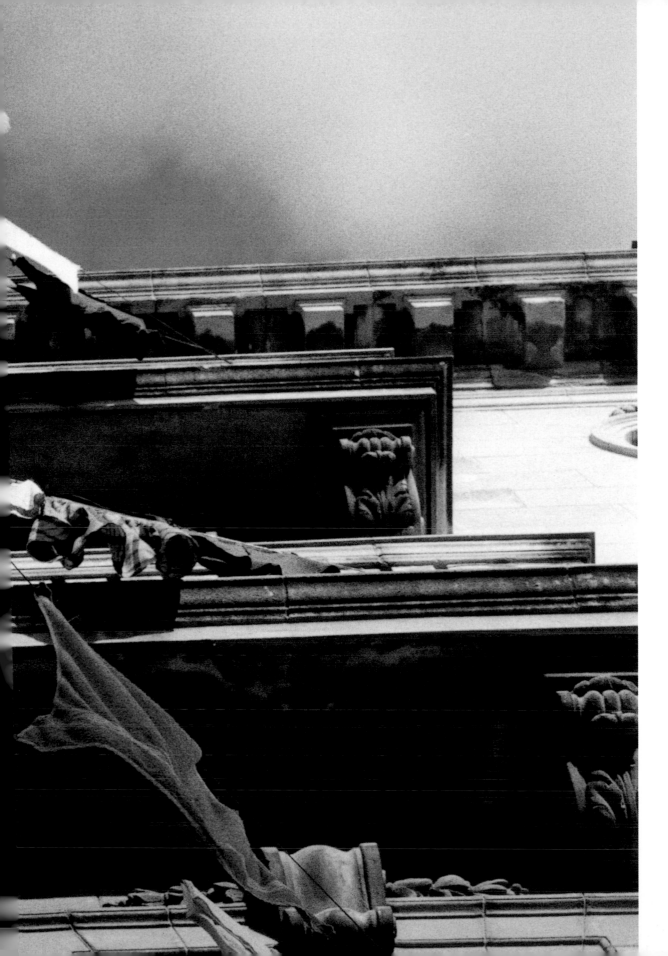

Balconies, Laundry Banners,
Havana, December 1998

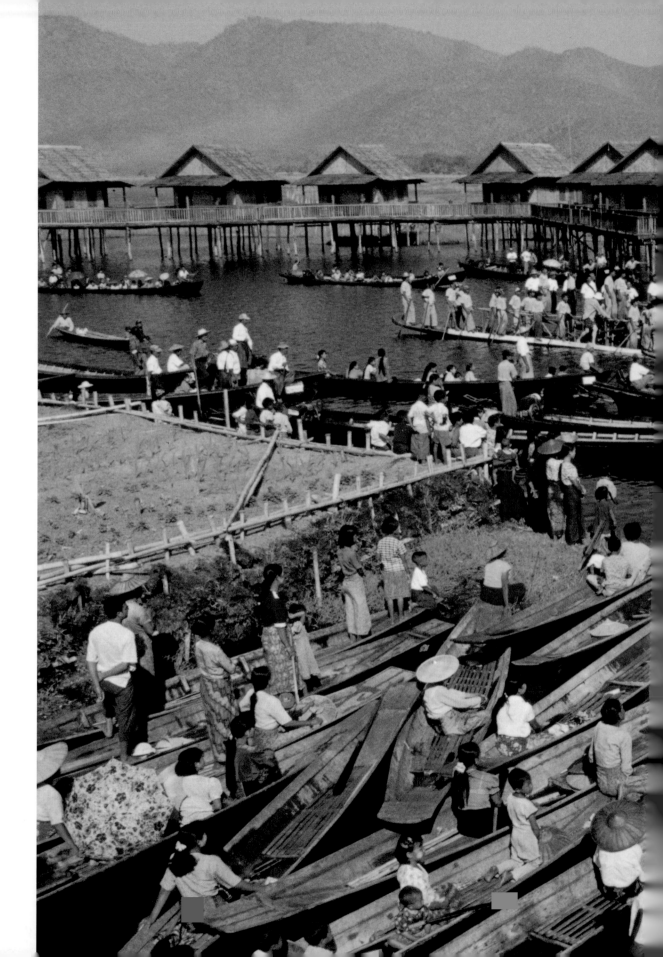

After the Boat Race,
Inlé Lake, Myanmar, 1998

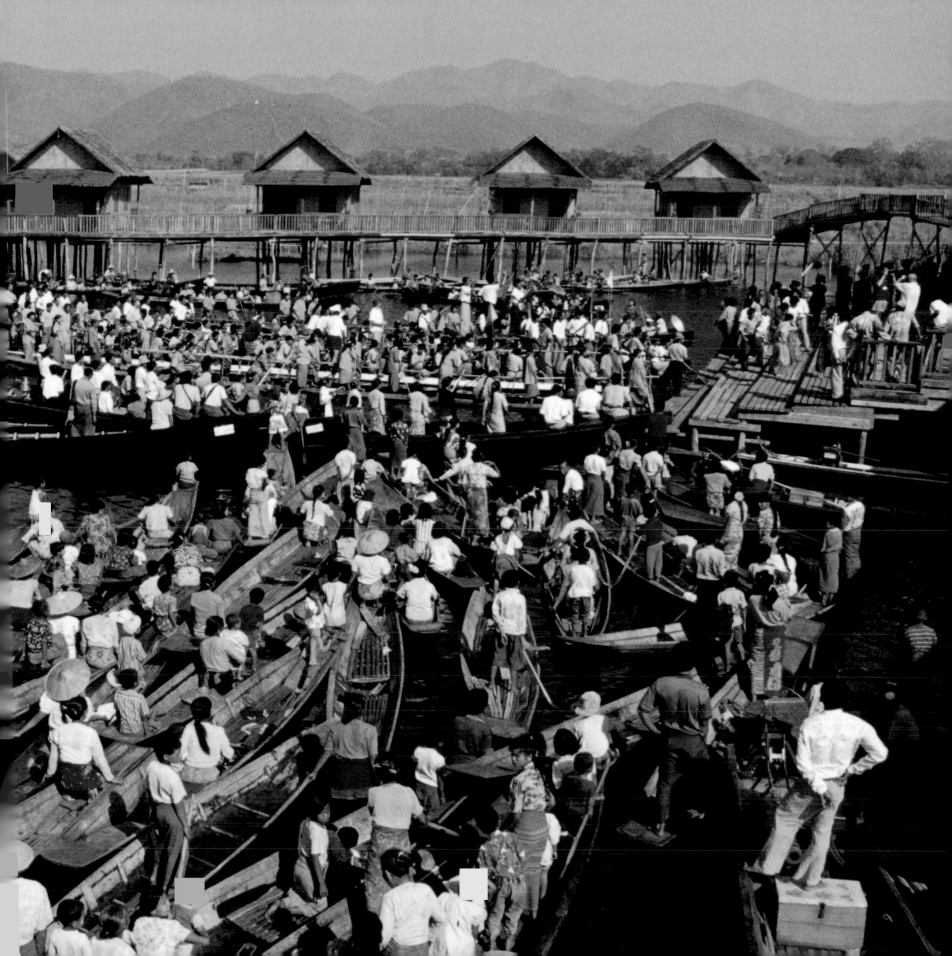

VII

The Human Face

STRIKING INDIVIDUALS *crossed my path as I traveled around the world—*
from children playing cards on a comfortable rug on the streets of Saigon to
the floating mail carrier who meets the ferry every day on the trip across the
Andes. Buses and boats brought us from Porto Monte in Chile to Bariloche in
Argentina. The gentle, loving attitude toward children in Myanmar (Burma)
is reflected in the portraits of a mother with her child and a father obviously
assigned to baby-sitting duty.

Yet the tough, sneakered woman in Havana asked for two dollars before
she allowed me to take her photograph, which I was happy to pay. She knew what
she was doing, and so did I.

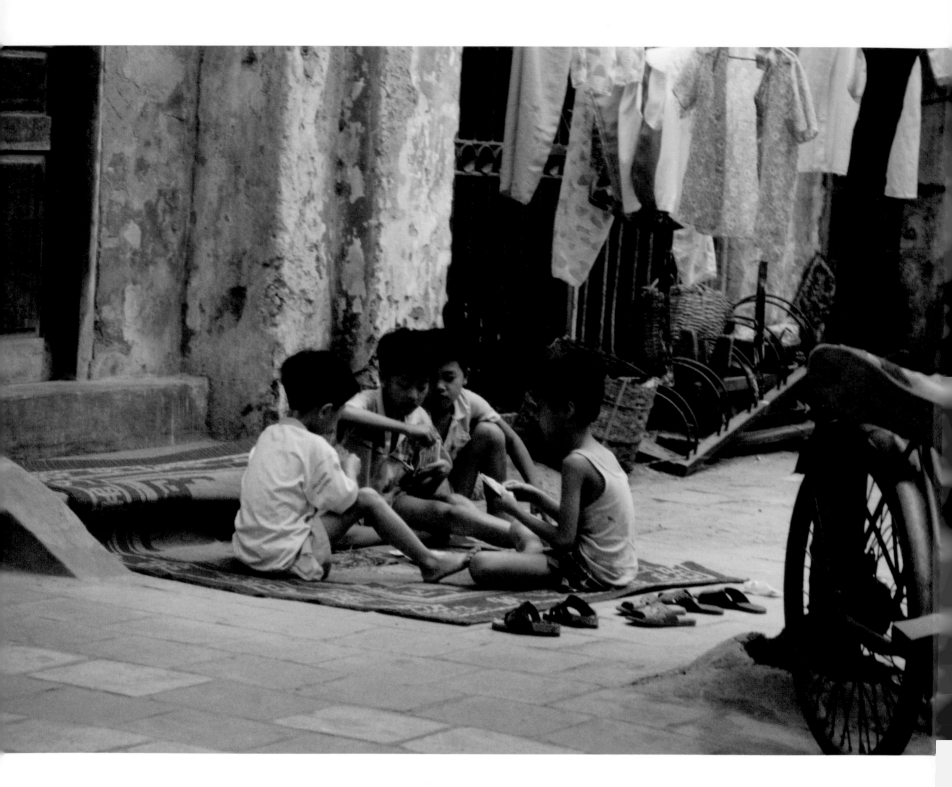

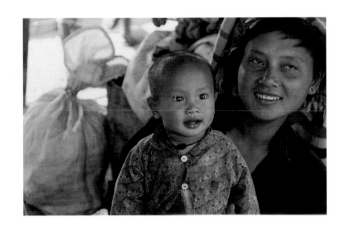

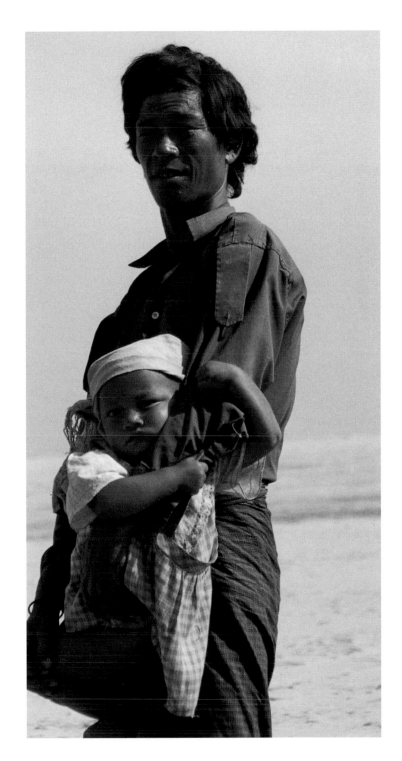

OPPOSITE

Card Sharks, Saigon, Vietnam, May 1995

———

ABOVE

Mother and Child Near Pagan Village, Myanmar,
March 1998

———

RIGHT

Father's Love, Irrawady River, Myanmar,
March 1998

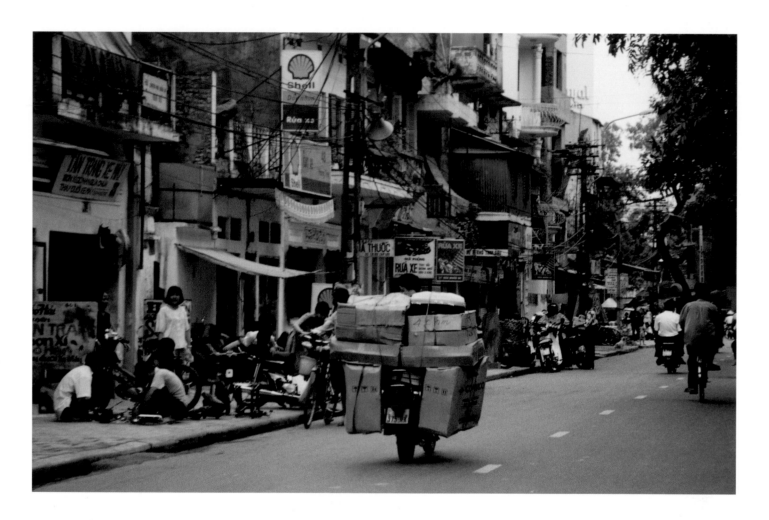

ABOVE

Where's the Bike?, Saigon, Vietnam, May 1995

———

OPPOSITE

Handsome Man Between Chile and Argentina, 1999

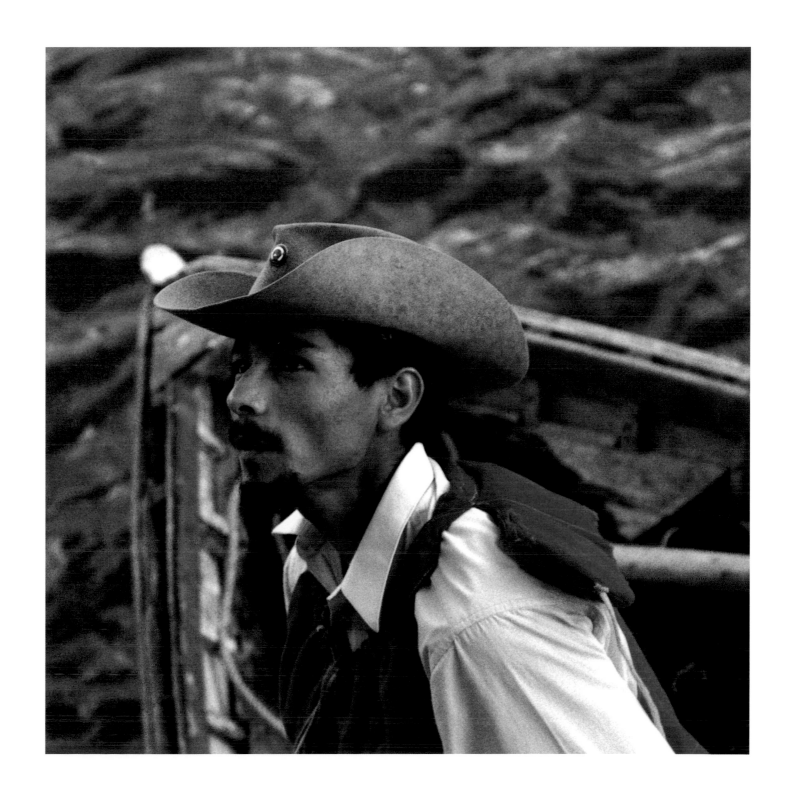

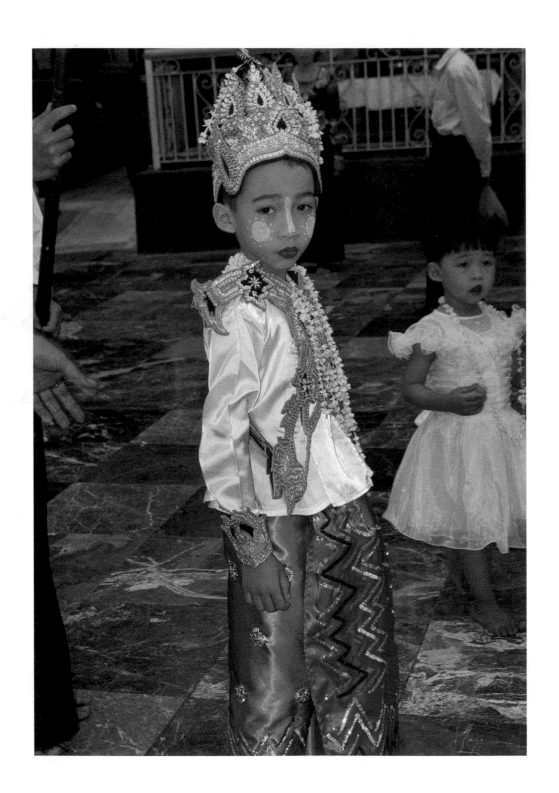

Ceremony Before Priesthood,
Myanmar, March 1998

The Cuban Carmen, Havana, 1998

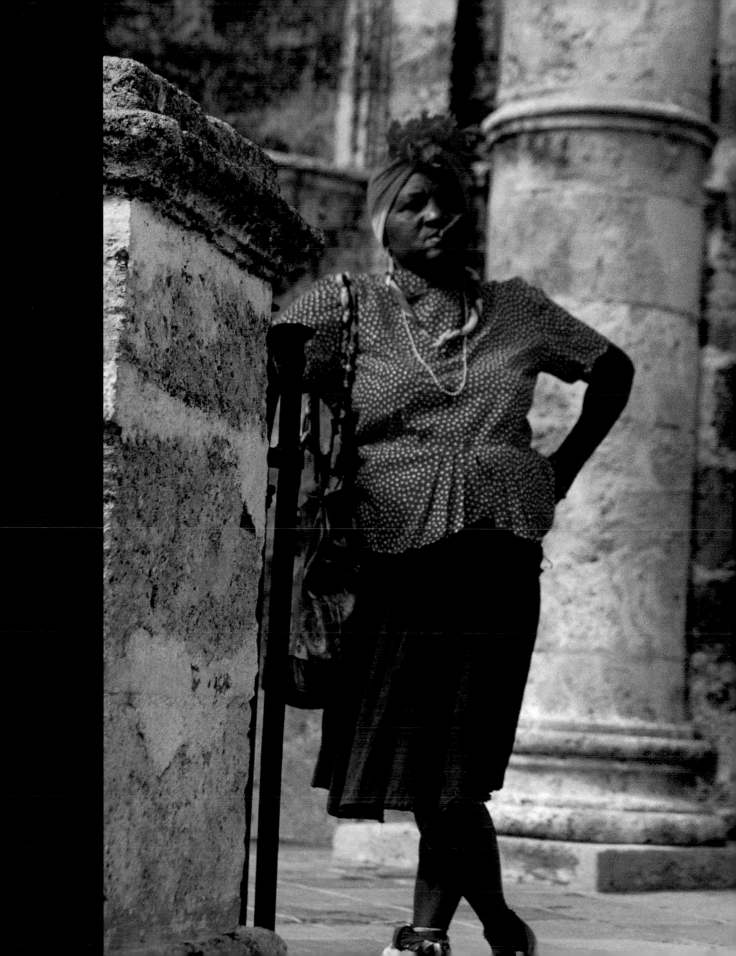

EXHIBITIONS

2002 Winston Wächter, Fine Art, Seattle, Washington

Harley Baldwin Gallery, Aspen, Colorado

John Berggruen Gallery, San Francisco, California

Pace/MacGill Gallery, New York City

Gagosian Gallery, Beverly Hills, California

2001 Mecox Gardens, Southampton, New York

The Gallery at 717 Fifth Avenue, New York City (Group Exhibition)

2000 The Jerusalem Centre for the Performing Arts, Jerusalem, Israel

White-Meyer Galleries, Washington, D.C. (Group Exhibition)

The Gallery at 717 Fifth Avenue, New York City (Group Exhibition)

1999 The Chase Manhattan Private Bank, Palm Beach, Florida

Arthur Ross Gallery, University of Pennsylvania, Philadelphia (Group Exhibition)

1998 Adelson Gallery, The Aspen Institute, Aspen, Colorado

Winston Wächter Fine Art, New York City

Nationsbank Private Client Group, Palm Beach, Florida

Bob and Penny Fox Student Art Gallery, University of Pennsylvania, Philadelphia (Group Exhibition)

1997 College Center Gallery, Vassar College, Poughkeepsie, New York

Tamron/Bronica Exhibition at the View Gallery, New York City (Group Exhibition)

1996 Kohn Pederson Fox Gallery, New York City (Group Exhibition)

Arthur Ross Gallery, University of Pennsylvania, Philadelphia (Group Exhibition)

1995 John Berggruen Gallery, San Francisco, California

1994 Holly Solomon Gallery, New York City

Pitkin County Bank, Aspen, Colorado

Robin Rice Gallery, New York (Group Exhibition)

1992 Holly Solomon Gallery, New York City

PUBLIC COLLECTIONS

Brooklyn Museum of Art, Brooklyn, New York

The Chase Manhattan Bank, Miami, Florida

The Chase Manhattan Private Bank, Palm Beach, Florida

Dana-Farber Cancer Institute, Boston, Massachusetts

Estée Lauder Companies, Inc., New York City

Evelyn H. Lauder Breast Center, Memorial Sloan-Kettering Hospital, New York City

The Haven Trust Day Centre, London, England

Israel Museum, Jerusalem, Israel

Jerusalem House, Atlanta, Georgia

Nationsbank, Palm Beach, Florida

New York Hospital, New York City

New York University Medical Center, New York City

Rena Rowan Breast Center, University of Pennsylvania Medical Center, Philadelphia

St. Luke's Roosevelt Hospital, New York City

Swedish Hospital, Seattle, Washington

The Whitney Museum of American Art, New York City

Evelyn Lauder's photographs were taken with several generations of the Olympus IS series camera.